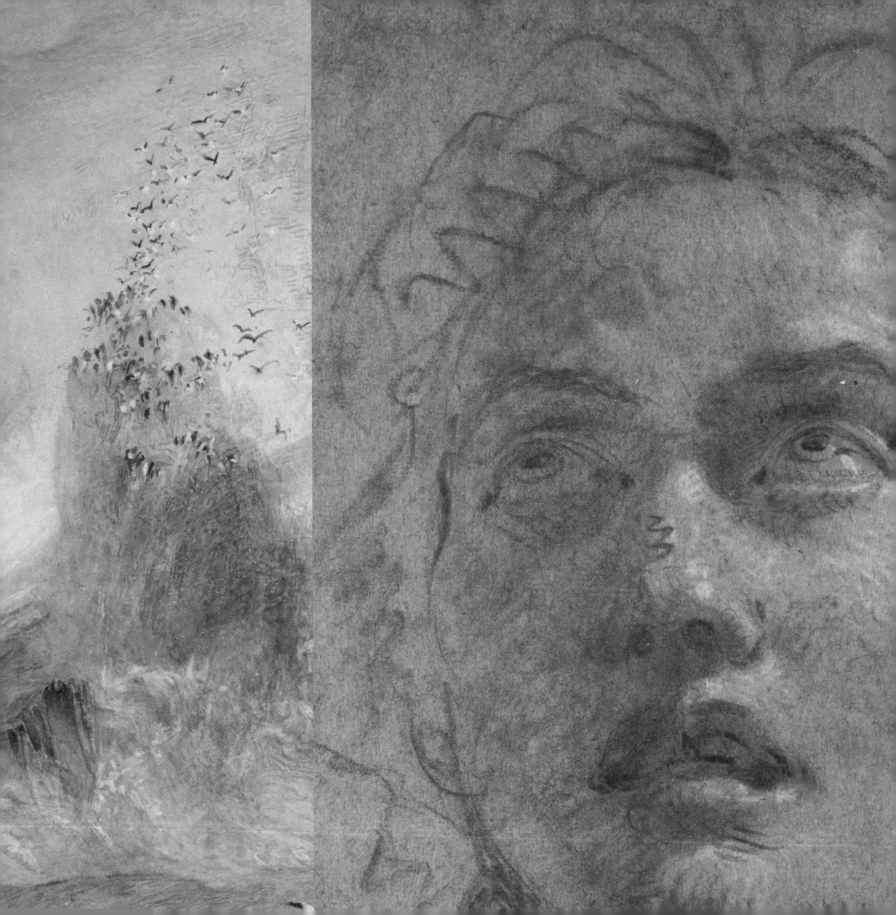

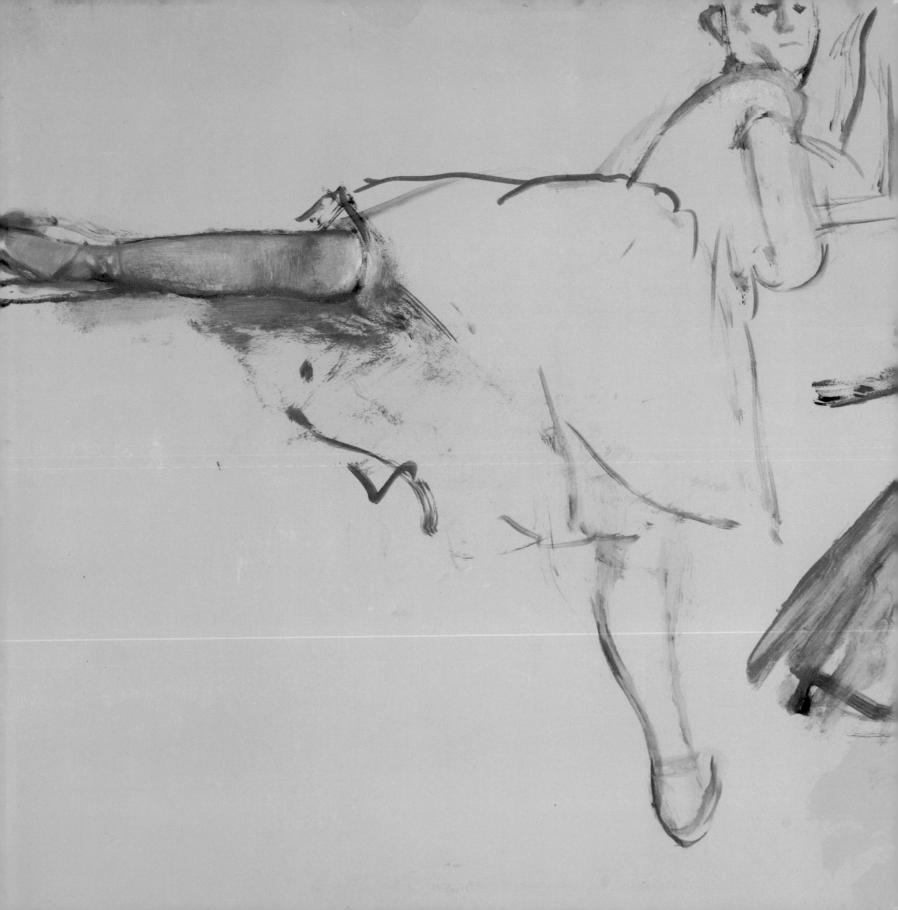

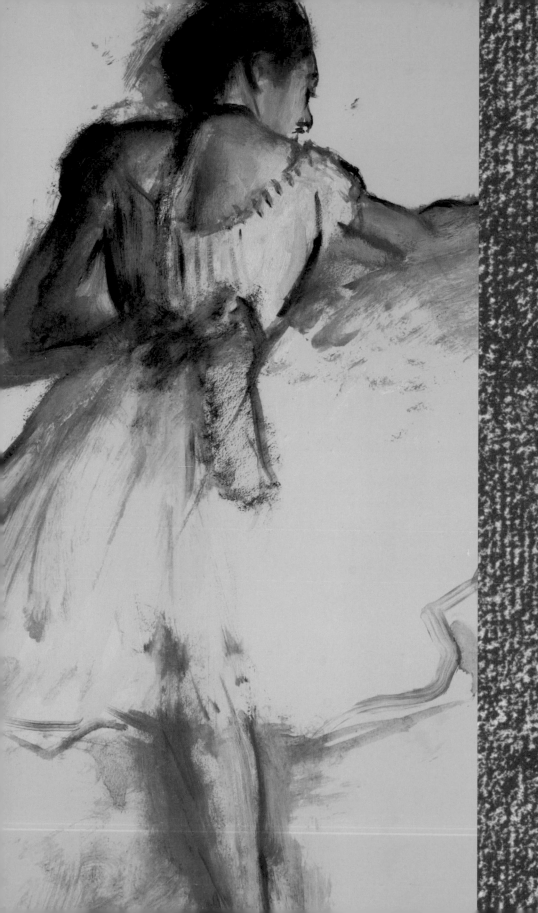

MASTER

DRAWINGS
CLOSE-UP

JULIAN BROOKS

THE J. PAUL GETTY MUSEUM | LOS ANGELES

Dedicated to my parents, Tim and Ann.

—J.B.

Published by the J. Paul Getty Museum, Los Angeles

Getty Publications
1200 Getty Center Drive, Suite 500
Los Angeles, California 90049-1682
www.getty.edu/publications

Gregory M. Britton, *Publisher*
Ann Lucke, *Managing Editor*
Catherine Lorenz, *Designer* and *Typesetter*
Elizabeth Chapin Kahn, *Production Coordinator*

Front cover: Théodore Géricault, *Studies of Horses* (detail; no. 34)
Back cover: Odilon Redon, *Head of Christ* (detail; no. 45)
Pages i–v: See nos. 39, 31, 41, 42; p. xii: no. 29; pp. 109–110: nos. 43, 44.

Library of Congress Cataloging-in-Publication Data

Brooks, Julian, 1969-
 Master drawings close-up / Julian Brooks.
 p. cm.
 Includes bibliographical references.
 ISBN 978-1-60606-019-3 (pbk.)
 1. Drawing, European. 2. Drawing--Appreciation. I. Title.
 NC225.B76 2010
 741.9--dc22

 2009033492

CONTENTS

ACKNOWLEDGMENTS

LOOKING AT WORKS OF ART may be a very personal activity, but producing a book is not. I appreciate greatly the help, kindness, and cooperation of a large number of people in creating the book you now hold. At the most senior level, in particular, Michael Brand, Director of the J. Paul Getty Museum, and David Bomford, Associate Director for Collections at the Getty, have supported the project from its inception.

I have spent many happy moments looking at drawings in the Museum's Paper Conservation Studio with the paper conservator Nancy Yocco, and I have benefited greatly from her knowledge and experience. She has kindly reviewed the text of the book and prepared some of the photographs. Senior Curator of Drawings, Lee Hendrix, has generously supported this project, helped to shape it, and given precious encouragement and advice, as have my colleagues in the Department of Drawings, who guided me with their knowledge and good judgment: Édouard Kopp, Stephanie Schrader, Laura Patrizi, Rachel Sloane, and Victoria Sancho Lobis. Michael Smith worked to ensure the highest quality photographic images for the publication.

At Getty Publications I would like to thank the publisher, Greg Britton; Mark Greenberg; and particularly Ann Lucke for their help and enthusiastic support. Rob Flynn, Elizabeth Kahn, Dominique Loder, Leslie Rollins, Karen Schmidt, and Deenie Yudell all played vital roles in bringing the book to fruition, and I am grateful to Catherine Lorenz for the clear and elegant design. Cindy Bohn was a masterful editor of the text.

At the British Museum, the hugely respected Antony Griffiths and staff of the Department of Prints and Drawings—Giulia Bartrum, Hugo Chapman (who gave excellent suggestions for the Introduction and Brief Guide to Terms), Mark McDonald, Martin Royalton-Kisch, and Angela Roche—have been generous colleagues and friends. They have provided me with the benefit of their great experience and knowledge and afforded me

unfettered access to the collections. I am thrilled that the book could be copublished with the British Museum, and Rosemary Bradley, publisher, and her team at British Museum Publications have made this a productive and happy partnership.

Lastly, I would like to thank the numerous friends and colleagues in the art world from whom I have striven to learn, and who make the drawings field a sympathetic, fun, and interesting one in which to work and play. My former Ashmolean colleagues and Oxford friends deserve special mention: Catherine Whistler, Colin Harrison, Jon and Linda Whiteley, David Franklin, and Larissa Haskell. Sylvana Barrett, who knows so much about historic materials and techniques, kindly looked over the Brief Guide to Terms and gave good advice, and Roy Perkinson provided a wealth of information about blue paper. Lena Kopelow was a steadfast and inspiring partner throughout. As I wrote this book, I tried to think of the sort of publication I desired as I first became interested in the field of old master drawings. I hope that it might serve to introduce a few people to the great pleasure and interest I have myself enjoyed.

Julian Brooks
Associate Curator, Department of Drawings
The J. Paul Getty Museum

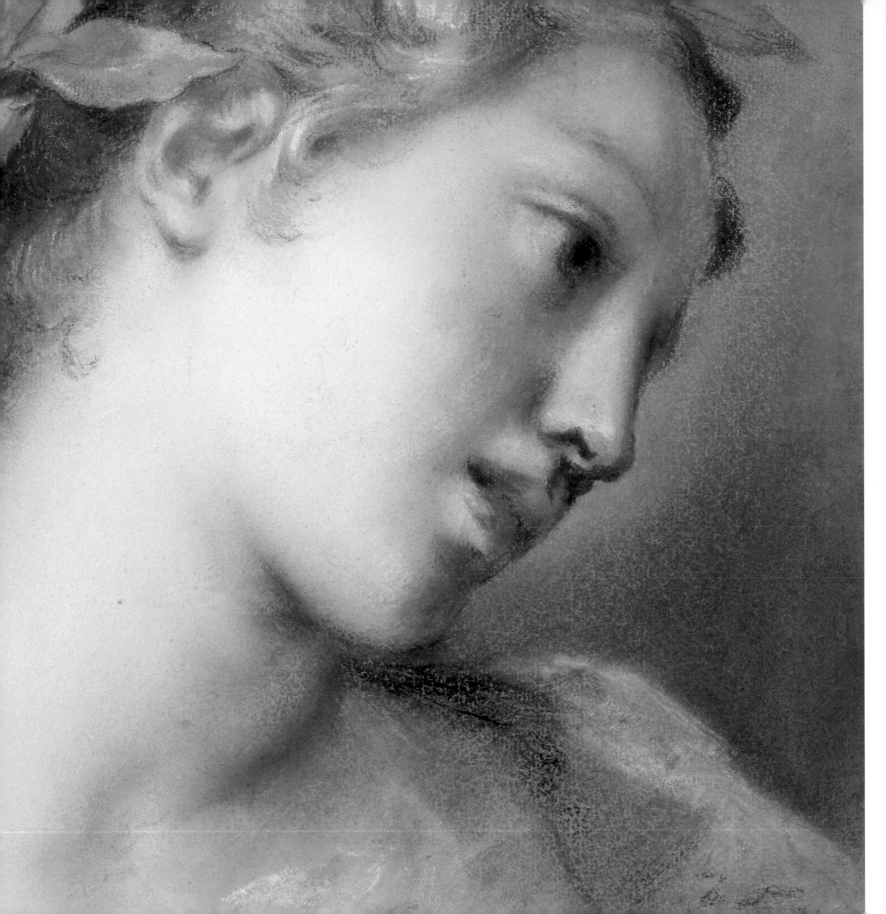

INTRODUCTION

THE PURPOSE OF THIS BOOK is to introduce the reader to the pleasure of looking at master drawings. Through the presentation of large-scale details, the book simulates the experience of looking at a drawing through a magnifying glass; we can see the techniques and materials used and get close to the artist's creativity. The drawings are from the collections of the J. Paul Getty Museum and the British Museum, reflecting their strengths in European drawings up to the year 1900. The drawings are roughly ordered by date and were chosen for inclusion here because, in addition to yielding beautiful details, they encompass a wide variety of media and techniques. The short texts are not intended to be comprehensive but rather to highlight particular aspects of each work; *italicized* technical terms are explained in the Brief Guide to Terms at the back of the book. Given the easy availability of information on the Internet, artists' biographies have not been included; some online resources are noted in the Further Reading section.

What I love about looking at a master drawing is the sense of being close to the artist, of seeing inspiration and creativity firsthand. As we engage with these works, we can almost hear the pen scratch across the sheet or feel that we are seeing three-dimensional space being created with chalk on a blank piece of paper. Master drawings provide a glimpse behind the scenes, beyond the final product the artist wanted us to see, enabling us to understand the human struggle involved, false starts and failed ideas included. The centuries of time between us and the artists seem to drop away, and we are there beside them as they work.

Accessibility

Looking at drawings in a museum or gallery is an intimate experience. Given the small scale of most drawings, only one or two people can look at a drawing at a time, and the viewer has to move in close to see much at all. Close looking at a work is amply rewarded,

and—like with most things—the more one investigates a drawing, the more interesting it becomes. In an ideal world, a viewer would be able to stand in a gallery or sit in a study room for some time and be able to revisit works on a regular basis, but the pressures of the modern age make that difficult.

Because paper is fragile and drawings are very vulnerable to damage by light, museums and galleries with drawings collections do not leave these works on permanent display. In order to make drawings available to their visitors, while still protecting them to the fullest extent possible, many museums rotate the displays in their galleries, normally putting works on view for no more than about three months at a time. Other museums have study rooms at which appointments can be made to see specific drawings. Sometimes, as with the British Museum, an appointment is not even needed, and the study room is openly available to the general public with the presentation of identification. Museum Web sites often provide a wealth of information and sometimes catalogues or databases with high resolution images, which viewers can browse at their leisure and prior to visiting the gallery or study room. Some details are given at the back of this book.

Damage by Light

Damage of drawings by light is a legitimate concern. The paper can become brown and brittle with overexposure (think of what happens when a newspaper is left out in the sun), and pigments in watercolors and washes can completely lose their hue. With this in mind, it is important to find a balance between making sure that people can see and enjoy drawings and preserving them so that future generations do not look back at us with dismay and contempt. Low light levels, changing displays, and the use of ultraviolet-filtering glass or Perspex are all helpful. Unfortunately, one all too often sees works that have been marred by overexposure in past centuries, when people were unaware of, or less concerned by, the damage that can be caused by light.

Accidents of Survival

That drawings survive in such numbers is extraordinary. Most served only a transitory role in the process of preparing to make a painting or other work of art. Some were kept in the artist's workshop because they represented useful tools for future commissions, others were cherished as records of an individual master's inventive touch by his students and pupils. Some artists clearly looked after their drawings as a storehouse of ideas, whereas others did not: the Bolognese painter Annibale Carracci is said to have cleaned dirty pots with his studies. While drawing was generally regarded as a vital activity for artists, a few—Caravaggio, for example—apparently did not draw. In the case of most artists, only a small percentage of the drawings they made in their lifetimes survive. Whole sections of an artist's drawn oeuvre could be destroyed by fire, flood, or disregard. Some artists

destroyed works themselves; Michelangelo, for example, burned a pile of his drawings so that people would not see his working process. In general certain categories of drawings had a higher likelihood of being preserved, with more finished sheets more apt to be prized than rough working compositional drafts in which artists poured out ideas on the page. What happened after an artist's death was often crucial. As the artistic profession was for centuries often a dynastic one, an artist's stock of drawings might pass to family members or to favored students. It is telling that some of the most important early collectors of drawings—Giorgio Vasari, Sir Joshua Reynolds, Jonathan Richardson Senior (see nos. 24 and 30)—were artists themselves. Many sheets were kept in albums, which protected them from light and accidental damage. While the majority of master drawings are now in museums, there are still private collectors who build up collections through purchases at auction houses, which still hold regular auctions of original drawings, and through dealers.

Drawing or Painting?

A drawing can broadly be defined as a work of art or sketch executed by hand in drawing media and normally on paper. However, there is much blurring at the edges of this definition, since drawings can be made on vellum, as are works that are considered manuscript illuminations, and large, highly finished pastels on paper are often considered paintings. Rough oil sketches on canvas or paper are another gray area, some being mounted as drawings and some presented as paintings. While most drawings are preliminary studies for other works—often paintings, decorative arts objects, or prints—a minority were also made as independent works of art. These were often highly finished and highly colored and deliberately meant to mimic paintings (see, for example, nos. 26 and 29). The uniqueness of drawings and paintings distinguishes them from prints, which are intended to be produced in multiple impressions taken from a matrix by a variety of processes, including woodcut, engraving, and etching.

Function

One of the prime considerations when looking at a drawing is that of why it was originally made. To ask this question can help us understand why it takes the form it does, and why the artist might have chosen a particular format or medium, a pen or chalk, for instance. Did the artist intend other people to see it? Was it to be followed by other drawings? While some sheets were made as works of art in their own right, others were made at a particular stage of preparation toward the realization of a painting, decorative art object, or print. For example, artists used drawings to work out the placement of characters within a scene, such as in a *compositional study*, or to examine a particular aspect of the design, such as the lighting of a single figure or a detail of dress or expression. Often the

only evidence of the function of a drawing can be garnered from within the work itself and sometimes can only be arrived at by a full study of all the (surviving) preparatory drawings. Frequently, the purpose of a drawing cannot be known because the finished work for which it was made has been lost. However, artists also drew for practice, for friends, or for pleasure.

Connoisseurship

Given that most drawings are not signed or documented, how do we know who created them? The simple answer is that there is rarely absolute proof in such an identification, although over the centuries, collectors, scholars, curators, and other experts have slowly built up a body of knowledge that brings order to the diverse mass of drawings. The process by which this has been achieved is known as connoisseurship and consists of the ability to assess the quality of works of art, and ascertain their country, and perhaps region, of origin, and their likely date of execution. On the basis of this information, it is sometimes possible to identify the artist. Connoisseurship relies on the assumption that each artist has a distinctive style or "handwriting" that can be used to isolate his or her work. Connoisseurs base their judgments on experience, visual memory, and comparisons among works. Connoisseurship has played a role in Western art from Giorgio Vasari onward and is still practiced today. It involves several key elements: telling a copy from an original; using a judgment of quality to differentiate the hands of masters from their pupils; and placing a drawing in the context of an artist's working procedure and its place in the evolution of his style. The attribution of a drawing is generally the result of a consensus of specialist opinion—usually following active discussion—and can occasionally be aided by modern analysis of pigments, papers, and the use of infrared and ultraviolet imaging to detect drawn lines invisible to the naked eye. While there is now a core of drawings accepted as likely to have been made by most major artists, many collections still have numbers of anonymous sheets that await categorization. Connoisseurship can—to some degree—be mastered by anyone who takes the time and care to study and look.

All the above having been said, works of art, especially those as intimate and beguiling as drawings, do not require anything at first instance apart from the patience and time to study them attentively. Seek out exhibitions of drawings whenever you can; in the meantime, please enjoy this selection of close-up details.

THE DRAWINGS

1

Gentile Bellini (Italian, 1429?–1507)

A Turkish Woman

Ca. 1479–81
Pen and black ink, the outlines of the
figure incised (perhaps for transfer)
21.4 x 17.6 cm (8⅜ x 6⅞ in.)
British Museum, Pp,1.20

PROBABLY A NEAT COPY by Bellini derived
from his own on-the-spot sketches, this draw-
ing reflects the intense curiosity of the art-
ist occasioned by his historic visit to Istanbul
as the guest of Sultan Mehmed II. The draw-
ing combines a deliberately descriptive linear
clarity with a startlingly accurate rendition
of the figure in space. Within a fine struc-
ture of outlines Bellini has depicted edges
not only with lines but also with meticulous
zones of parallel *hatching*, such as on the
nose. Different densities of hatched lines and
cross-hatching provide volume and a sensi-
tive description of the fall of light. Bellini has
written *color notes* on the drawing to remind
him of aspects of the fabric and trimming:
"rosso" (red); "oro" (gold); and "arzento"
(Venetian dialect for *argento*, silver).

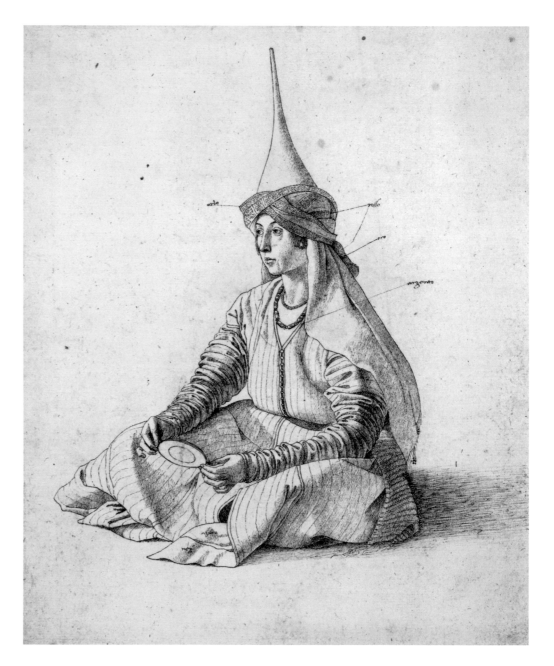

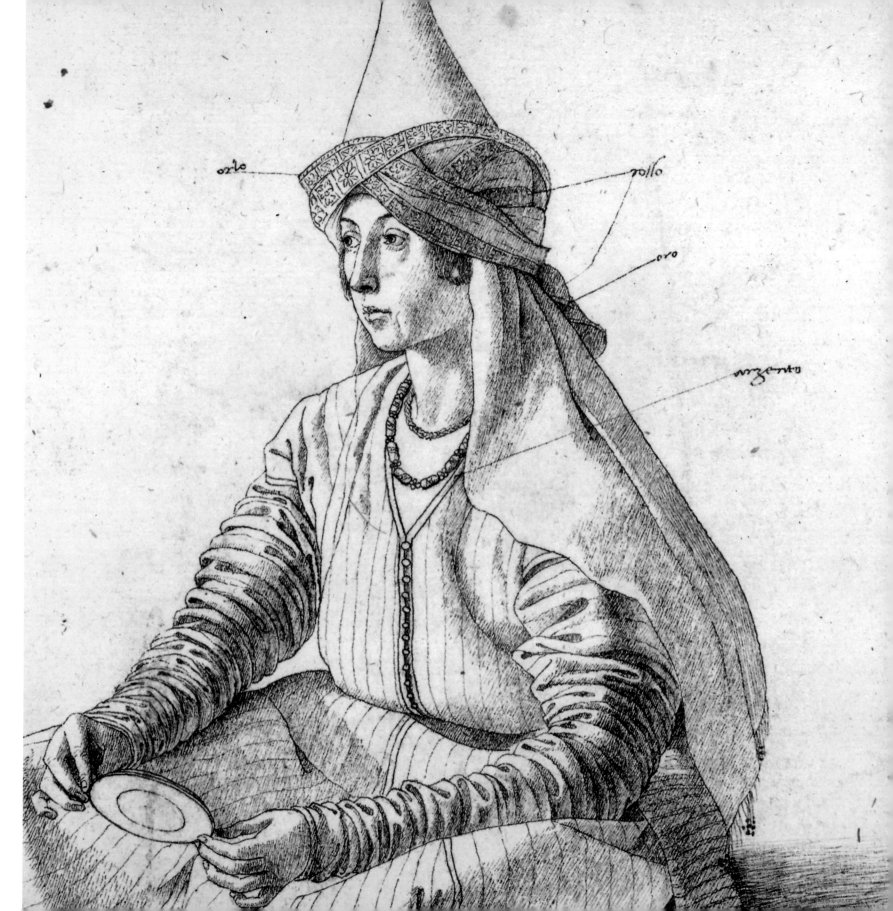

ozto

rollo

oro

arzento

2

**Circle of the Master of the Housebook
(German, active about 1470–1500)**

*Design for a Quatrefoil with a Castle,
a Maiden Tempted by a Fool, a Couple
Seated by a Trough, and a Knight and
His Lover Mounted on a Horse*

Ca. 1475–90
Pen and black ink
24.1 x 21.7 cm (9 ½ x 8 9⁄16 in.)
J. Paul Getty Museum, 2005.39

THE FOUR-LOBED SHAPE of this composi-
tion (the center would have been filled by a
coat of arms) reflects its purpose as a de-
sign for stained glass. Used and reused in
the workshop, many working drawings for
stained glass were destroyed through wear
and tear. On the right of the design an el-
egant woman is being wooed by a jolly fool
(identified by his jaunty foolscap with ass's
ears and bells), signifying the folly of love.
Small-scale playful scenes such as this would
have been suitable for enlivening a private
residence, while large-scale stained glass
with religious imagery was mostly intended
for churches and chapels.

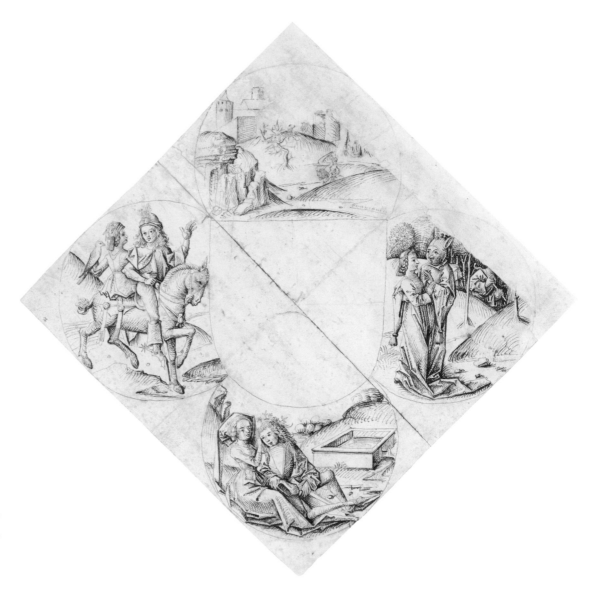

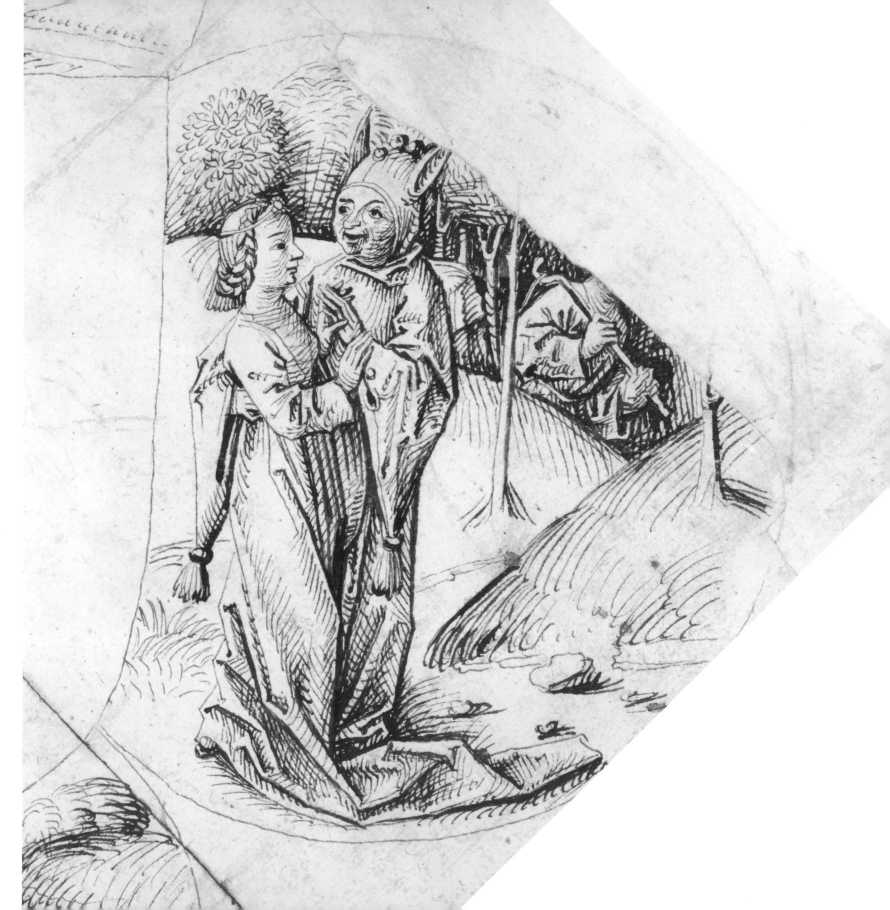

3

Leonardo da Vinci (Italian, 1452–1519)

Caricature of a Man with Bushy Hair

Ca. 1495

Pen and brown ink

6.6 x 5.4 cm (2⅝ x 2⅛ in.)

J. Paul Getty Museum, 84.GA.647

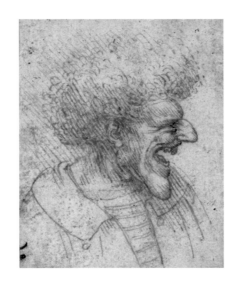

actual size

LEONARDO DA VINCI WAS fascinated by physiognomy. In a series of studies he examined fantastical human features in a profile view, traditionally used for noble portraits on ancient coins and medals. Here the *hatching* characteristic of left-handed artists (slanting from upper left to lower right, since the wrist or elbow is used as a pivot) is clearly visible. Leonardo used studies like this to teach pupils about human expression, and it is a funny quirk that in their copies many of his students—even the right-handed ones—imitated their master's left-handed hatching. Drawn on a tiny scale, this study was part of a larger sheet, probably containing six or more drawings, which was subsequently cut up by a collector.

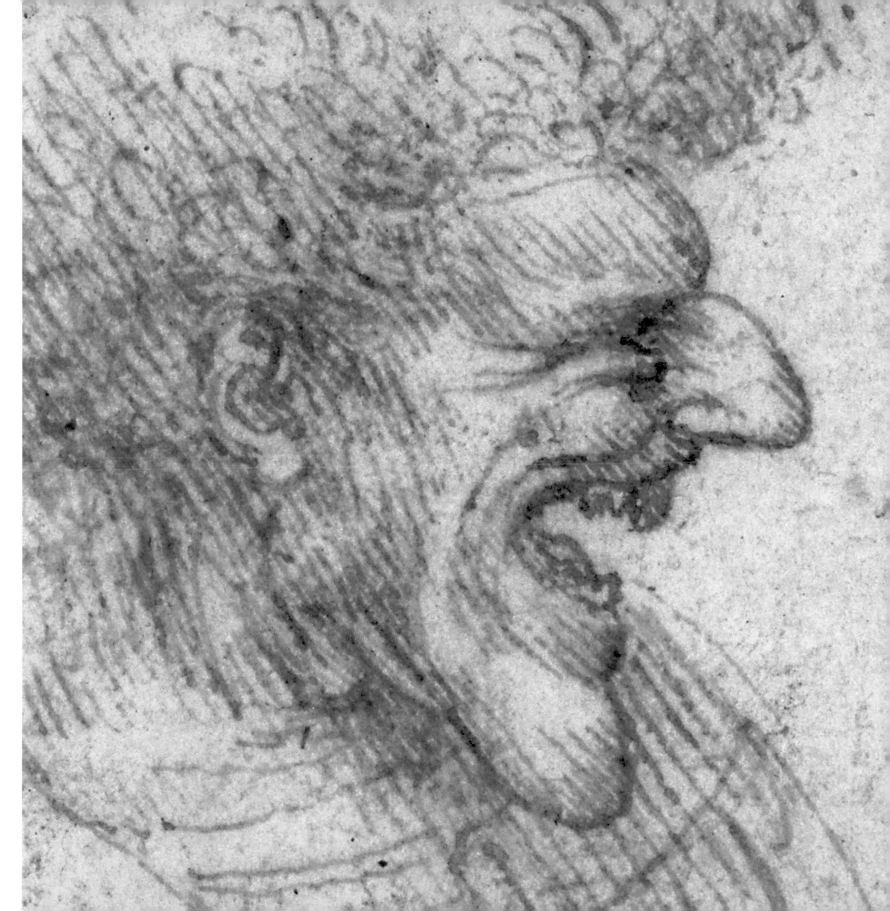

4

Albrecht Dürer (German, 1471–1528)

A Weierhaus

Ca. 1497
Watercolor and gouache
21.3 x 22.5 cm (8⅜ x 8⅞ in.)
British Museum, SL,5218.165

WITH A VARIETY OF delicate strokes of dark brown, yellow-green, and bright green *gouache*, Dürer here describes reedy waterside plants, in contrast to the free use of *watercolor* which builds the context of the scene. Touches of white gouache record foaming around the broken post and water's edge.

Having made landscape sketches (some of the earliest watercolors in Western art) on his travels to Venice about 1495, Dürer continued to study the scenery around Nuremberg after his return. His close observation of nature was as influential as his early adoption of the watercolor medium to capture faithfully the light, color, and topography of landscape scenes. As he wrote, "Life in nature reveals the truth of these things." Here Dürer depicts a timber-framed fisherman's cottage called a *weierhaus*; he notes this in a black ink inscription (*weier haus*) below. The AD *monogram* in brown ink was added by a collector at a later date.

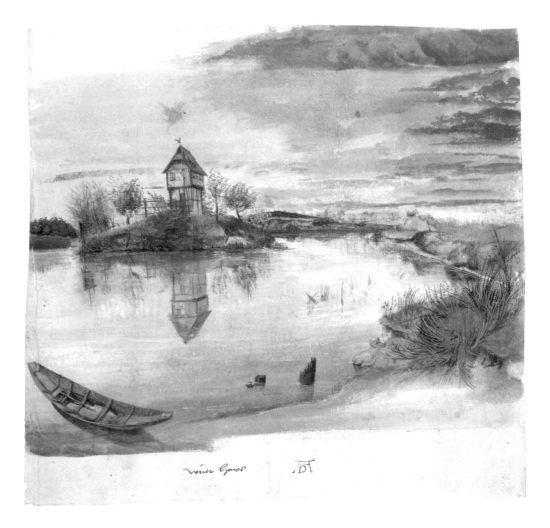

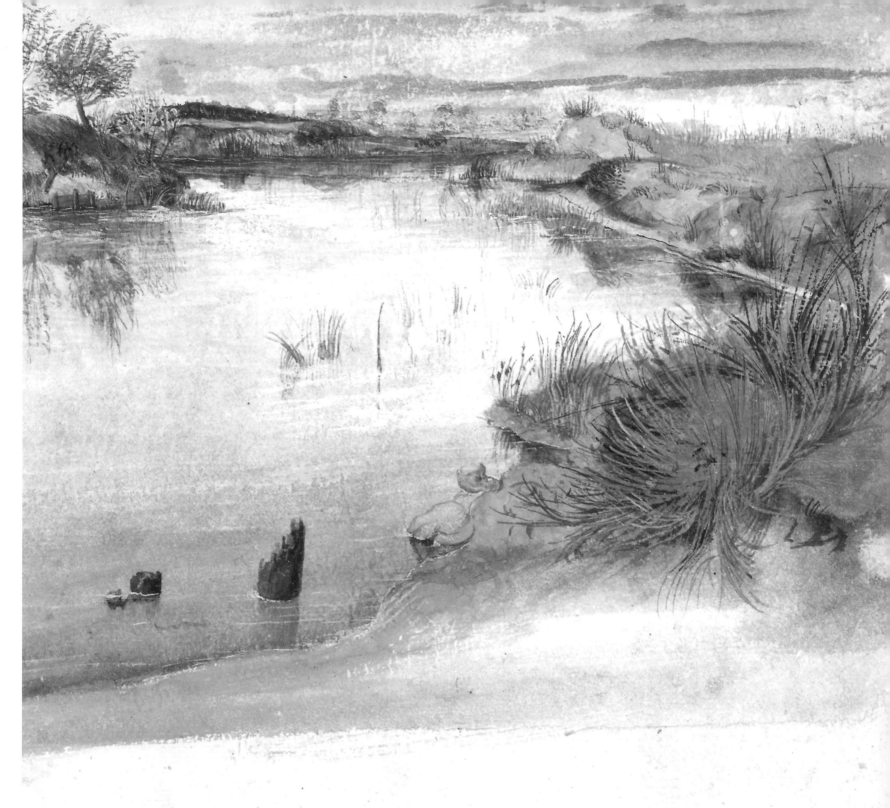

5

Leonardo da Vinci (Italian, 1452–1519)

Studies for the Christ Child with a Lamb
(recto); *A Child with a Lamb, Head of an*
Old Man, and Studies of Machinery (verso)

Ca. 1503–6
Pen and brown ink and black chalk
21 x 14.2 cm (8¼ x 5⁹⁄₁₆ in.)
J. Paul Getty Museum, 86.GG.725

LEONARDO DA VINCI PIONEERED this type
of "brainstorm" sketch, in which the paper
is used as a thinking pad to contain a wide
variety of studies; such drawings have since
become a standard part of artistic practice.
Leonardo drew on both sides of the sheet
of paper (the *recto* and the *verso*), chiefly
studying the motif of the Christ child playing
with a lamb. Initially, Leonardo made numer-
ous brief sketches of their interaction in *black*
chalk, some only faintly visible now. The most
satisfactory of these he worked over with ink
and a *quill pen* (ideal for such work because
of its flexible nib), and to one of them he then
added detail and *hatching*. The sheet is a tell-
ing reflection of Leonardo's intense creativity
and curiosity. At the top of the recto, notes in
the artist's mirror writing (probably the result
of his left-handedness) concern mathemat-
ics, while those on the verso discuss costume
design and annotate a sketch for a prototype
laminating device.

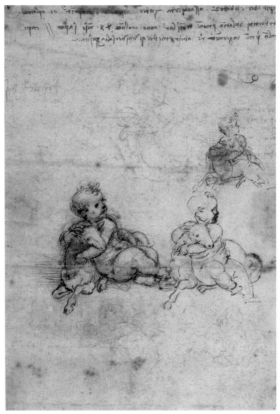

recto

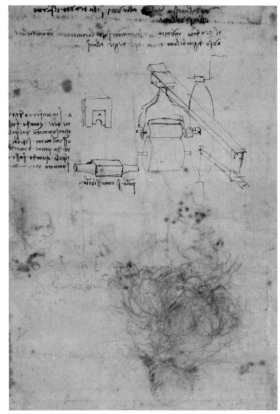

verso

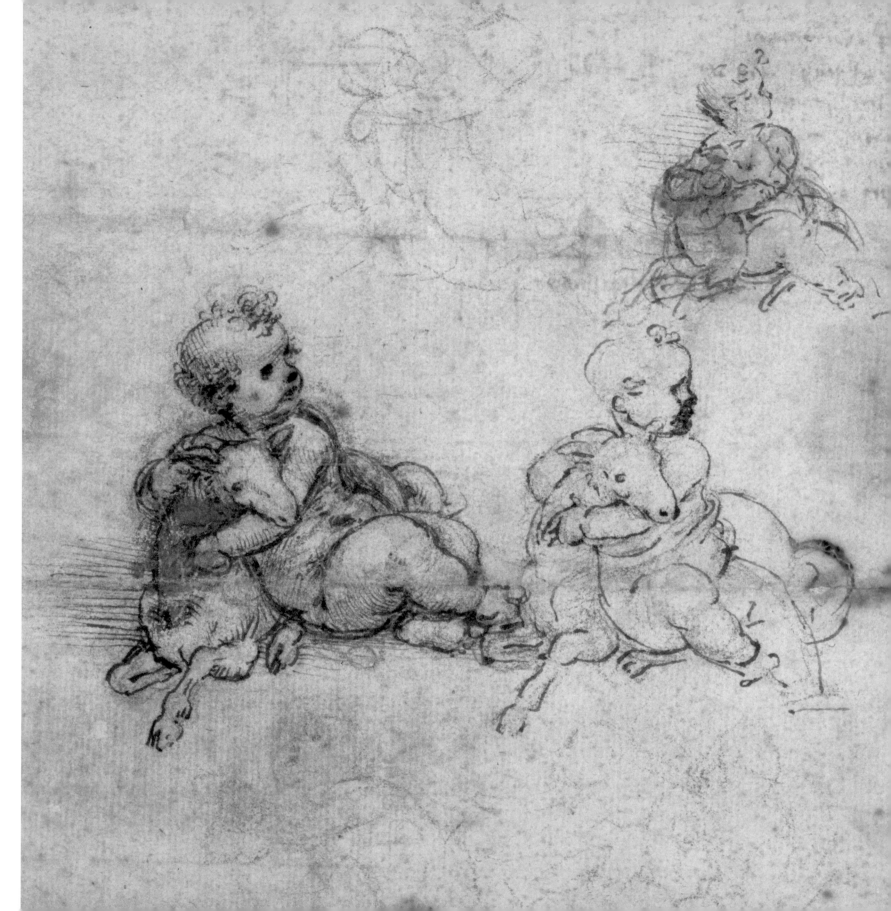

6

Fra Bartolommeo (Baccio della Porta)
(Italian, 1472–1517)

Madonna and Child with Saints

1510–13
Black chalk, with traces of white chalk;
incised lines used for the top arch
37.5 x 28.3 cm (14¾ x 11⅛ in.)
J. Paul Getty Museum, 85.GB.288

IN THIS *COMPOSITIONAL STUDY* for an important painting commissioned by the Florentine republic, Fra Bartolommeo arranged the various figures to create a unified work and examined the relationship between them. He selected *black chalk* because it enabled the creation of a broad tonal range on the white paper (very dark and very light patches, and every tone in between). Its softness in this case facilitated drawing areas of shadow, and much of the composition is conveyed through the disposition of light rather than through contour or descriptive line. Subtle effects created by rubbing or *stumping* are used to modulate delicate shadows on faces; Fra Bartolommeo's use of *sfumato* and his concern with *chiaroscuro* show Leonardo da Vinci's influence.

7

Michelangelo Buonarroti
(Italian, 1475–1564)

Study of a Reclining Male Nude

Ca. 1511
Red chalk over stylus underdrawing
19.3 x 25.9 cm (7⅝ x 10¼ in.)
British Museum, 1926,1009.1

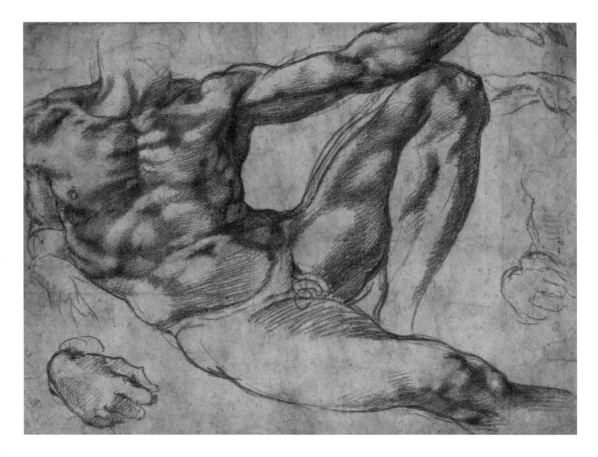

IN THE PROCESS OF making studies for the myriad of figures he painted on the ceiling of the Sistine Chapel in the Vatican, Michelangelo created numerous drawings from posed models, often in *red chalk*. In this study for the figure of Adam in the fresco, Michelangelo is particularly interested in the fall of light on the chest area and the muscles around the shoulder of the upraised arm; an arching line marks the junction of the deltoid with the bicep. While a sense of three-dimensional solidity is achieved by hatched chalk lines of different pressures, the boundaries are established by the outlines, often the result of several searching trial strokes, as along the top of the thigh. To rough out the figure on the page, Michelangelo drew these first with a *stylus*. In the final painted fresco he greatly simplified the level of detail in his rendition of the figure; such subtlety as found here would have been invisible from so far away on the ground below.

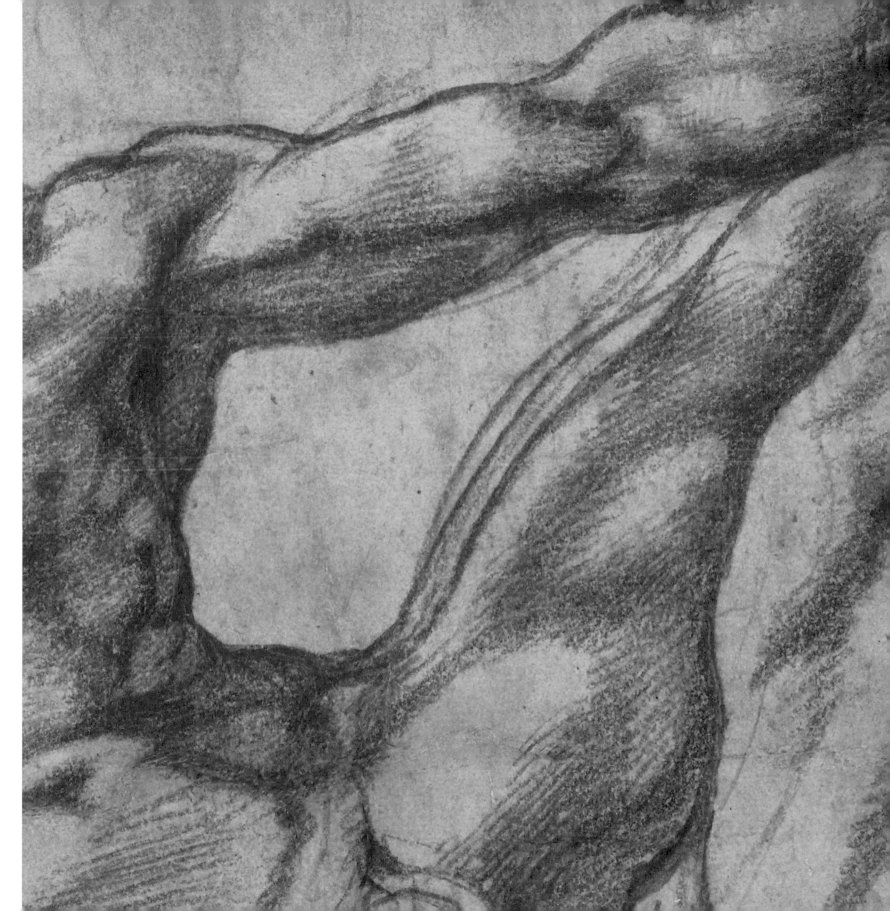

8

**Niklaus Manuel Deutsch
(Swiss, 1484–1530)**

The Mocking of Christ

Ca. 1513–14
Pen and black ink with white and gold
highlights on red-brown prepared paper
54.1 x 21.7 cm (21⁵⁄₁₆ x 8⁹⁄₁₆ in.)
J. Paul Getty Museum, 84.GG.663

TO MAKE THIS HIGHLY decorative and pow-
erful *independent work* of art, Manuel began
by brushing the whole sheet of paper with a
red-brown *wash* (*prepared paper*). The vio-
lence of the scene is conveyed through exag-
gerated gestures and facial expressions, and
the thuggish characters have been drawn in
black ink with *highlights* of white *gouache*
applied with the point of a brush. Playfully,
Manuel has positioned the right foot of the
steeply *foreshortened* figure in the fore-
ground so that it breaks his own *framing
line*. Manuel combined his artistic activities
with side work as a mercenary soldier, and
he signed the drawing with the *monogram* of
his initials above a Swiss dagger (or *Schweiz-
erdolch*, probably a word play on his name).

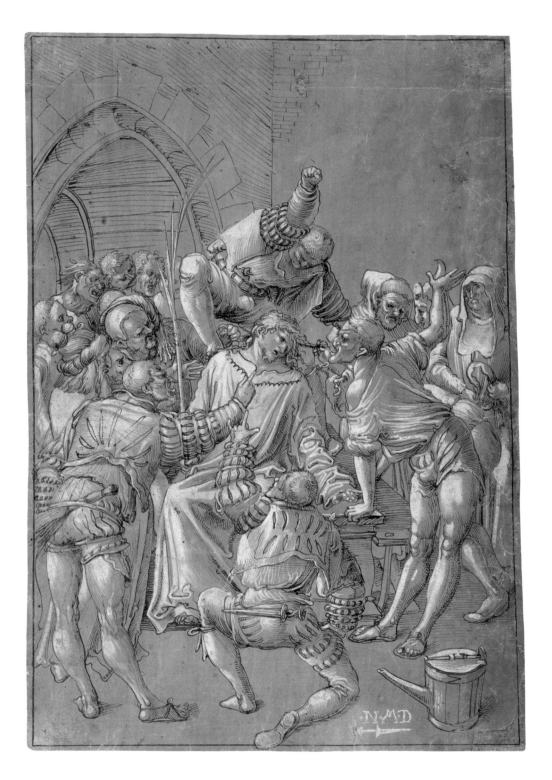

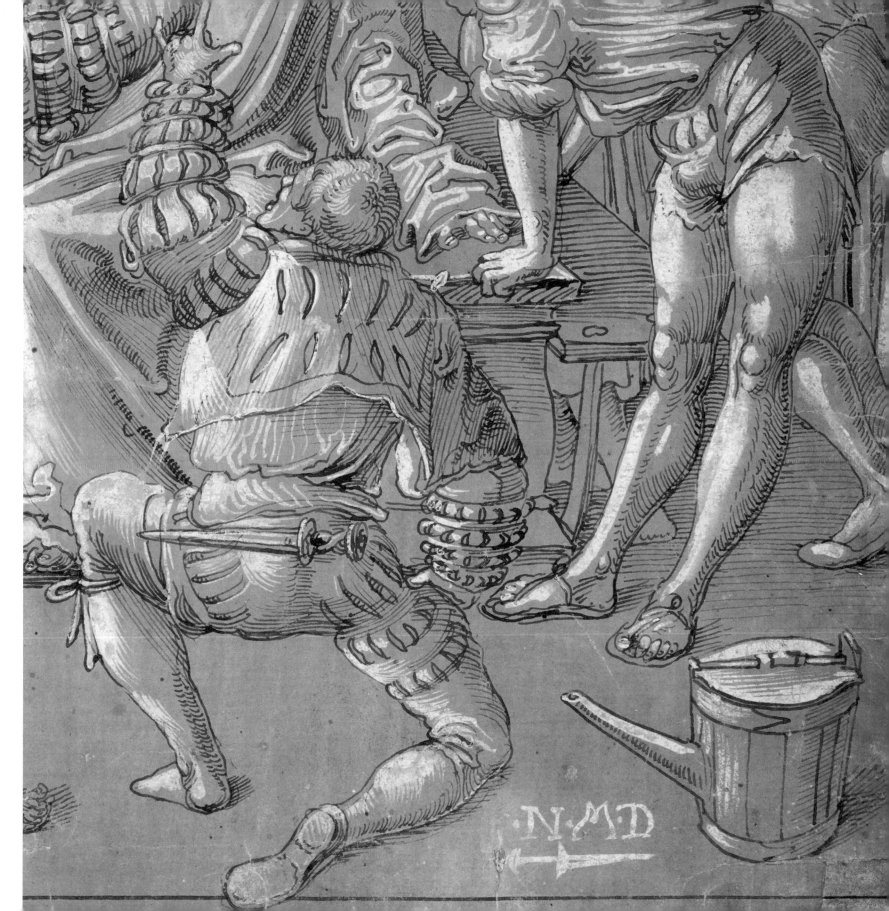

9

Raphael (Raffaello Sanzio)
(Italian, 1483–1520)

Saint Paul Rending His Garments

Ca. 1515–16
Metalpoint heightened with white
gouache on lilac-gray prepared paper
23 x 10.3 cm (9 1/16 x 4 1/16 in.)
J. Paul Getty Museum, 84.GG.919

THE SOFT, GHOSTLIKE effect of this draw-
ing was created by Raphael's use of the *met-
alpoint* medium. After preparing the sheet of
paper with a thin lilac-gray coating (*prepared
paper*) to render the surface slightly rough,
Raphael worked with a metalpoint/stylus,
probably of silver, to capture the lights and
shadows of the figure and the fall of his drap-
ery. Metalpoint was respected for its diffi-
culty, since the lines cannot be easily erased.
Various grades of *hatching* convey darkness
in the folds of the drapery, while a thick liq-
uid white *gouache* applied with a brush rep-
resents strong light on the side of the figure.
Although most artists moved to the simpler
media of *black* or *red chalk* when they be-
came available, Raphael continued also to
use the older, labor-intensive metalpoint
medium until his death at the age of thirty-
seven. This drawing is a study for the figure
of Saint Paul for a composition representing
the biblical episode of the Sacrifice at Lystra.

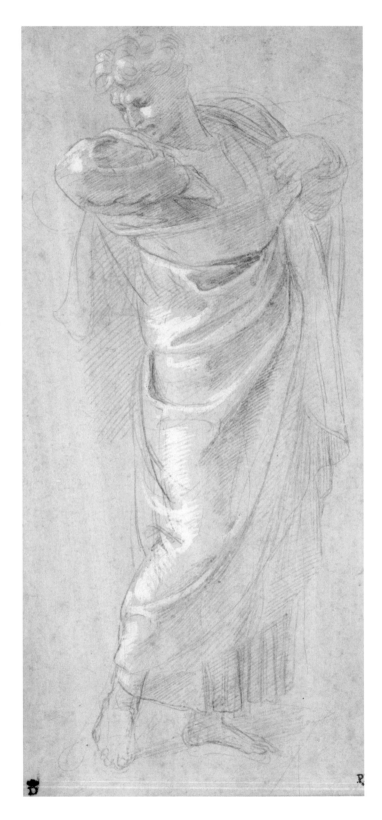

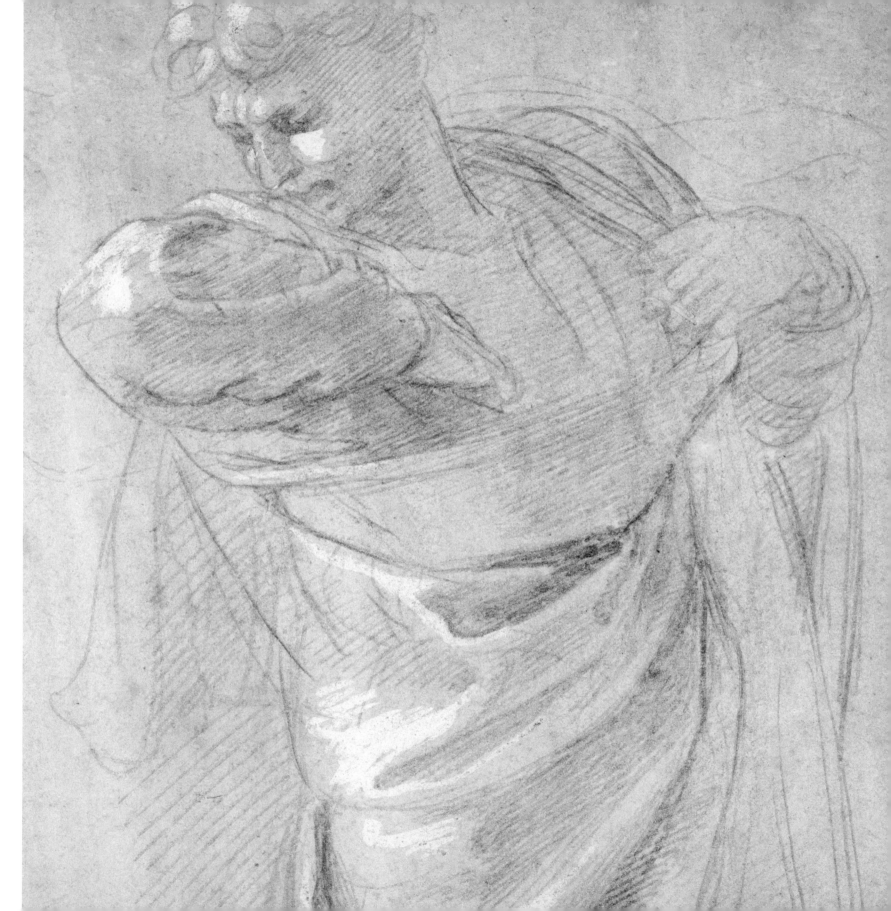

10

**Attributed to Baccio Bandinelli
(Italian, 1493–1560)**

*An Unidentified Subject, with Figures
Kneeling before a Bearded Man*

Ca. 1515
Red chalk
25.5 x 32.5 cm (10 x 12¾ in.)
(upper corners cut)
British Museum, Ff,1.18

THE ELEGANT SILHOUETTED figures at the back of this composition contrast with the play of natural light—and reflected light—in the foreground. In each case, the white of the paper is used to great effect. In the background it represents a strong outside light highlighting the outlines of the dark figures, while in the foreground *reserves* of paper create the opposite effect, highlighting the principal characters. Planes of space are shown by different strengths of *hatching* and *stumping*. The mysterious subject of the drawing, including murmuring ranks of elders (precisely drawn with a hard point of *red chalk*) and kneeling figures, possibly represents a biblical narrative from the desert wanderings of the Israelites.

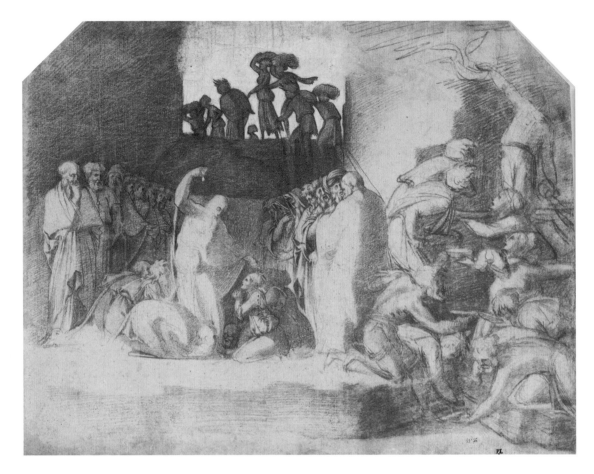

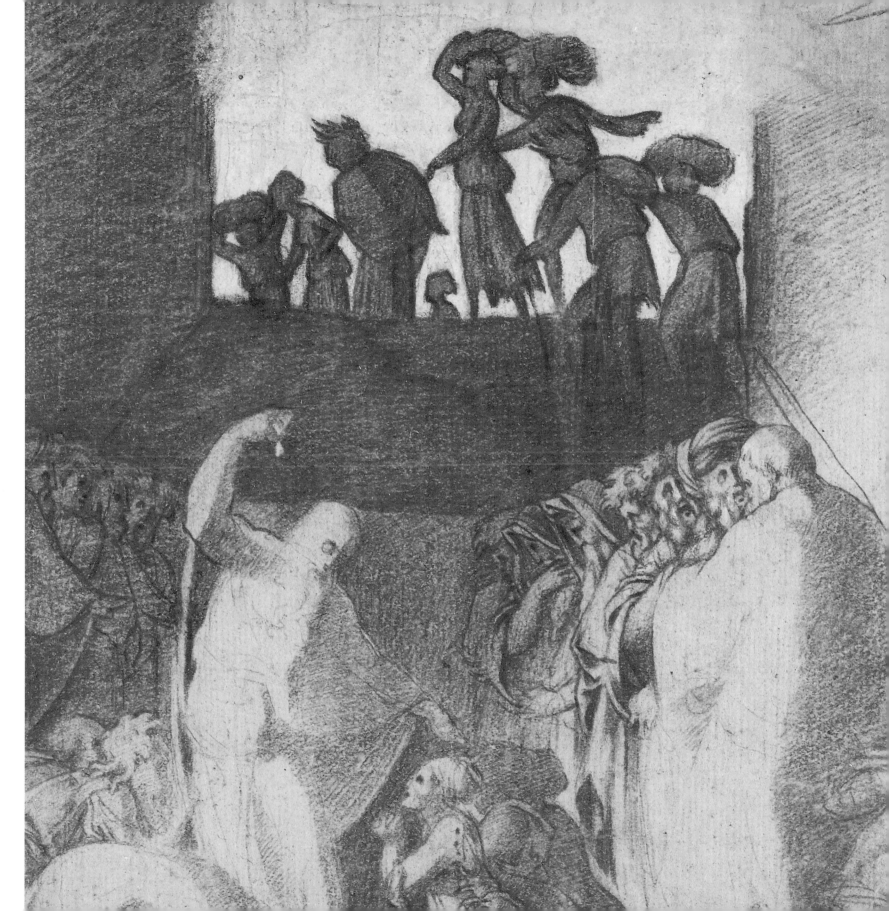

11

**Sebastiano Luciani,
called Sebastiano del Piombo
(Italian, ca. 1485–1547)**

Cartoon for the Head of Saint James

Ca. 1520
Black and white chalk, on two joined
sheets of tan paper; silhouetted; pricked
for transfer
30.2 x 30.5 cm (11⅞ x 12 in.)
J. Paul Getty Museum, 82.GB.107

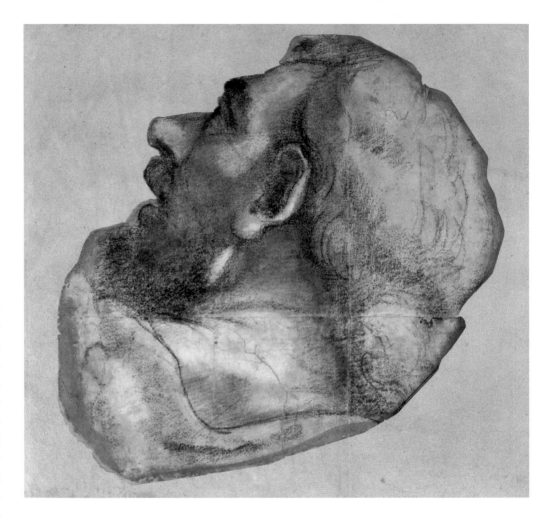

THIS SEEMINGLY DISEMBODIED head
was once part of a large *cartoon* made by
Sebastiano del Piombo to study the figure
of Saint James in full scale. The cartoon, cre-
ated prior to the painting of his fresco in the
church of San Pietro in Montorio, Rome, en-
abled Sebastiano, a close follower of Michel-
angelo, to anticipate aspects such as the fall
of light and shade so that they could be faith-
fully rendered in the fresco. The cartoon was
pricked for transfer to the fresco by *pounc-
ing* (the tiny pinholes can be seen around the
mouth, eye, and nose), and this fragment has
been *silhouetted* around the outlines of the
head. Sebastiano has here concentrated on a
three-dimensional modeling of the head, us-
ing *hatching* of *black chalk* and *white height-
ening* to accurately convey the fall of light,
including the way it catches the edge of the
ear and the tip of the nose.

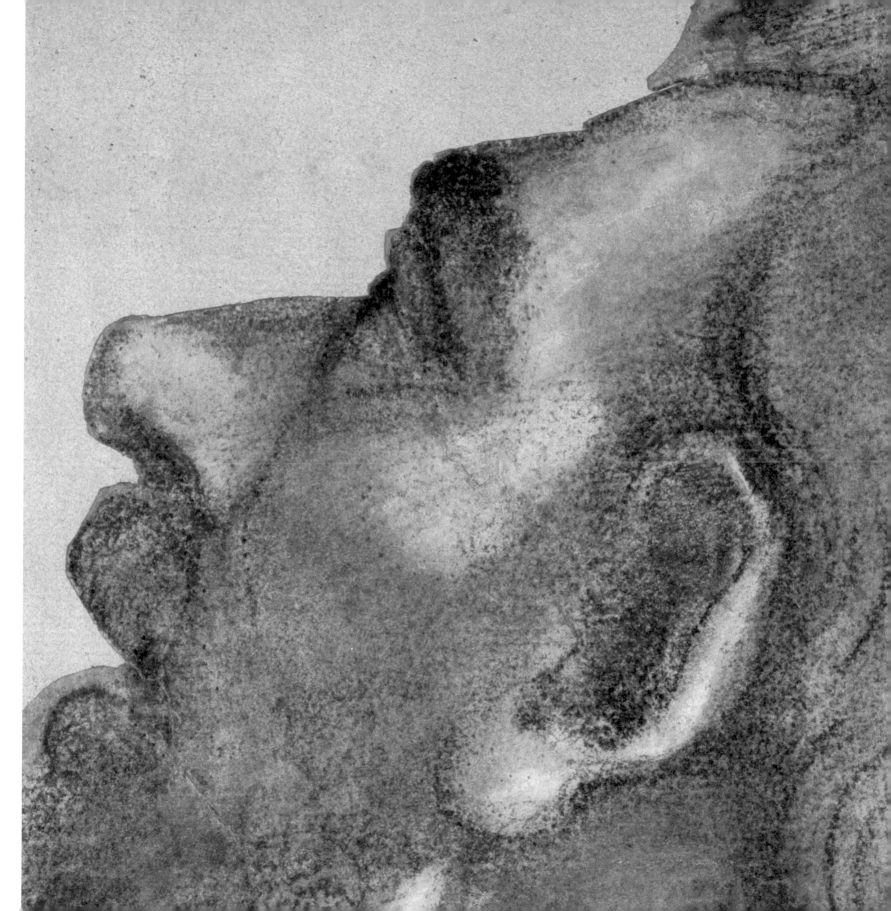

12

Andrea del Sarto (Italian, 1486–1530)

Study of Figures behind a Balustrade

Ca. 1525
Red chalk
17.5 x 20 cm (6⅞ x 7⅞ in.)
J. Paul Getty Museum, 92.GB.74

ONE OF THE FATHERS of modern drafts-manship, Andrea del Sarto is particularly known for his drawings in *red chalk*. On this sheet he has studied two ideas for depicting a figure behind a balustrade, possibly in con-nection with a project for the design of an embroidered altar frontal. Sarto's rapid work-ing method resulted in numerous *pentimenti*, as the artist explored different solutions. In particular, there is a prominent pentimento in the head of the right-hand figure, which is shown in at least three poses: looking down over his shoulder, looking straight ahead at his book, and gazing up to the sky.

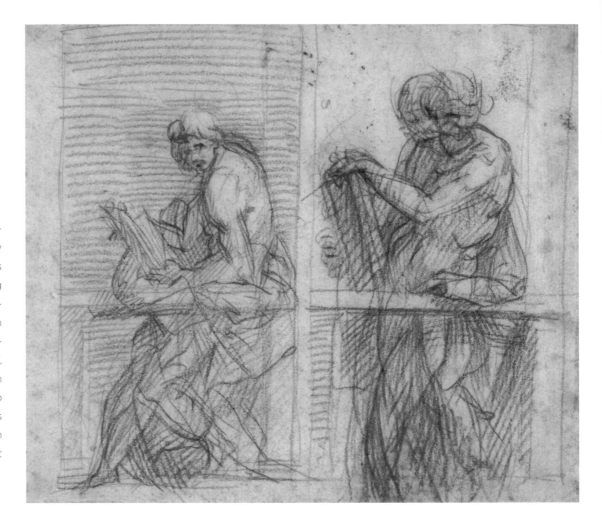

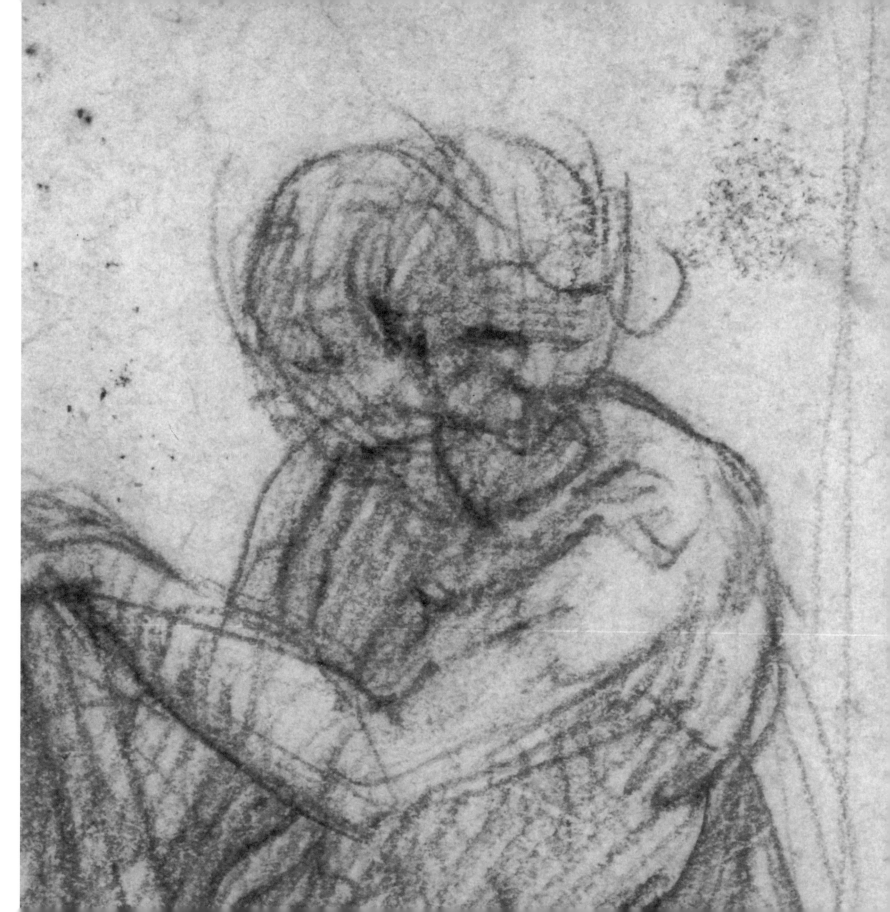

13

Giulio Romano (Giulio Pippi)
(Italian, before 1499–1546)

An Allegory of the Virtues of
Federico II Gonzaga

Ca. 1530
Pen and brown ink over black chalk, white
gouache used for corrections; incised
framing lines
24.9 x 31.8 cm (9¹³⁄₁₆ x 12½ in.)
J. Paul Getty Museum, 84.GA. 648

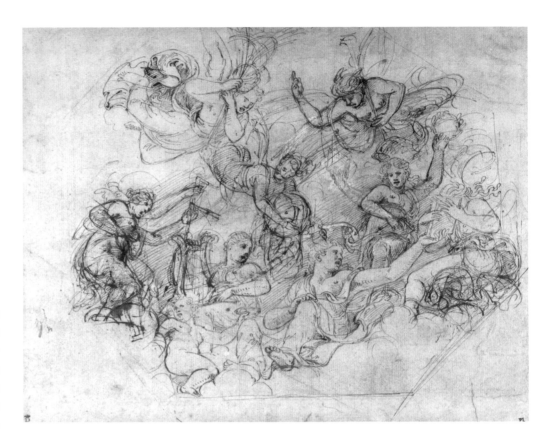

GIULIO ROMANO'S FERTILE imagination is
evident through the energetic flow of ideas in
this *compositional study*, a design for a ceil-
ing fresco in the Sala d'Attilio Regolo at the
Palazzo Tè, Mantua. The allegory, intended to
flatter his *patron*, Federico Gonzaga, shows
a seated personification of the city of Man-
tua receiving various attributes. The fluid-
ity of pen and ink allowed Giulio to explore
the complex arrangement quickly. Although
he changed his mind several times, he could
not erase the ink lines and instead used white
gouache as "white out" for the *pentimenti*
(visible in the right arms of two of the cen-
tral characters: flying Mercury and a woman
holding a wreath). Aware that this was a de-
sign for a ceiling, Giulio drew the figures as if
seen from below and used rough *incised* and
ink *framing lines* to plan the octagonal space
of the ceiling compartment.

 Near the legs of the figure at the fur-
thest left of the sheet Giulio had trouble with
his *quill pen*, which spilled splotches of ink on
the paper. Just outside the octagon to the
left he tested the pen with a few squiggles.

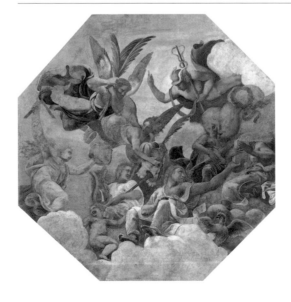

Giulio Romano, *An Allegory of the Virtues of
Federico II Gonzaga*, ca. 1530. Ceiling fresco in
the Sala d'Attilio Regolo, Palazzo Tè, Mantua
(Amedeo, Belluzzi, *Palazzo Tè a Mantova*
[Modena, 1998], p. 635).

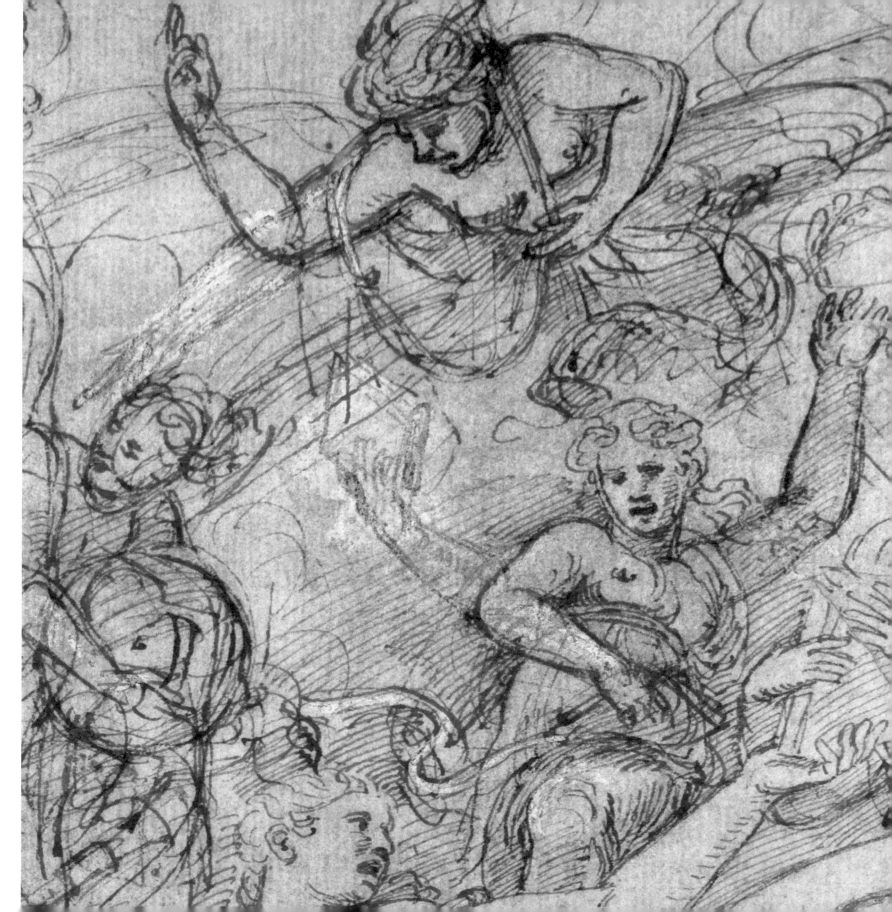

14

**Hans Holbein the Younger
(German, 1497/98–1543)**

*Portrait of a Lady, formerly thought
to be Anne Boleyn*

Between 1532 and 1543
Black chalk, partly stumped, and red
chalk; pen and brush with black ink; yellow
wash, on pale pink prepared paper
32.1 x 23.5 cm (12⅝ x 9¼ in.) (corners cut)
British Museum, 1975,0621.22

WHILE HOLBEIN, RENOWNED for his lifelike
portraits, used the point of a brush with black
wash for the fluid rendition of the dangling
headdress seen here, he employed a fine pen
with black ink for the outline of the facial fea-
tures, the open mouth, and delicate touches
such as the eyelashes. *Red chalk* was used for
the lips and also, realistically, for the glimpse
of the underside of the left eyelid.

　　The corners of this sheet have been
cut off, probably long ago. Drawings were
often kept in albums, which protected them
from light and wear and tear, and they were
frequently attached to an album page by glu-
ing the corners. Sometimes, to remove the
drawing easily from an album, the corners
were simply cut, and this may have been the
case here.

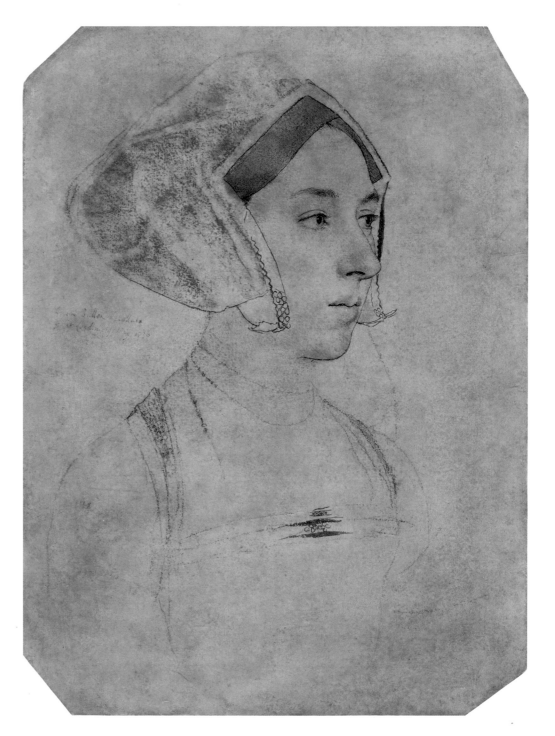

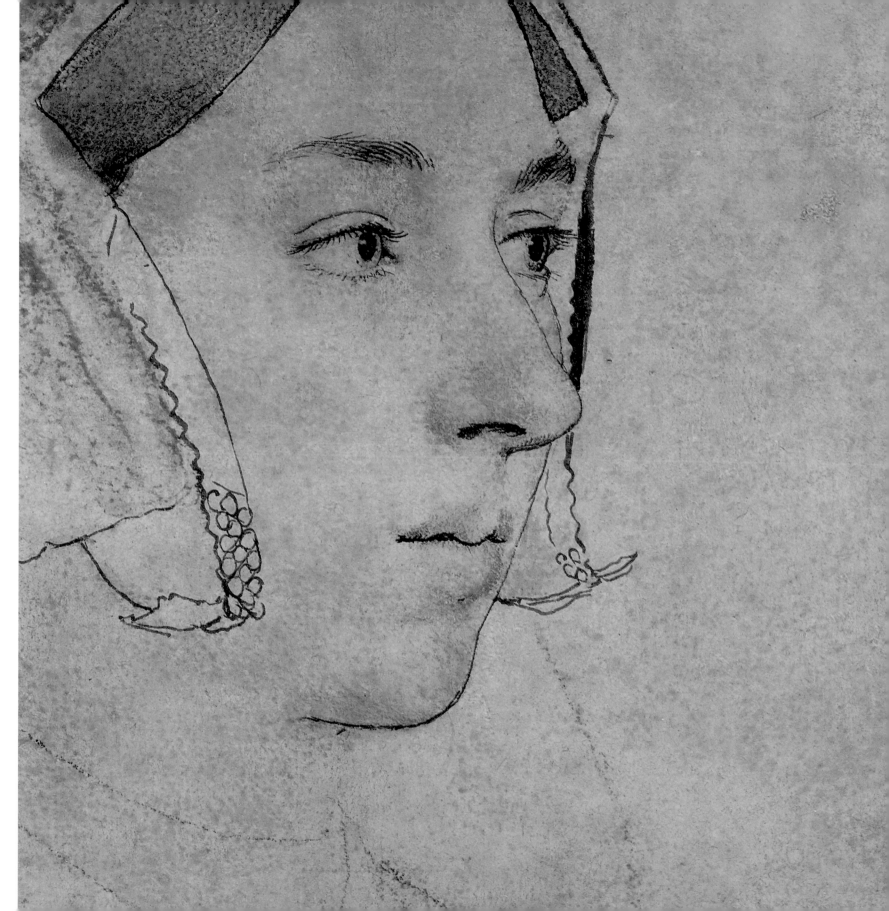

15

Jacques Le Moyne de Morgues
(French, ca. 1533–ca. 1588)

A Sheet of Studies with French Roses
and an Oxeye Daisy

Ca. 1570
Watercolor and gouache over black chalk
20.6 x 15.6 cm (8⅛ x 6⅛ in.)
J. Paul Getty Museum, 2004.52

THESE BOTANICAL STUDIES, representing
early examples of their type, were made in a
sophisticated combination of *watercolor* and
gouache. An intense purple watercolor wash
was used for the densest parts of the ros-
es, and this was lightened by a pinkishwhite
gouache for the petals catching the light.
These effects are subtly modulated, and
the texture of the thick gouache brilliantly
mimics the rich velvet feel of the petals. The
artist started with *underdrawing* in *black
chalk*, some of which is just visible along the
right-hand edge of the lowest rose study.
In 1564 Le Moyne de Morgues was an ex-
plorer on a French expedition to Florida, but
the colony was attacked by Spaniards. He
escaped and returned to France and later
moved to London.

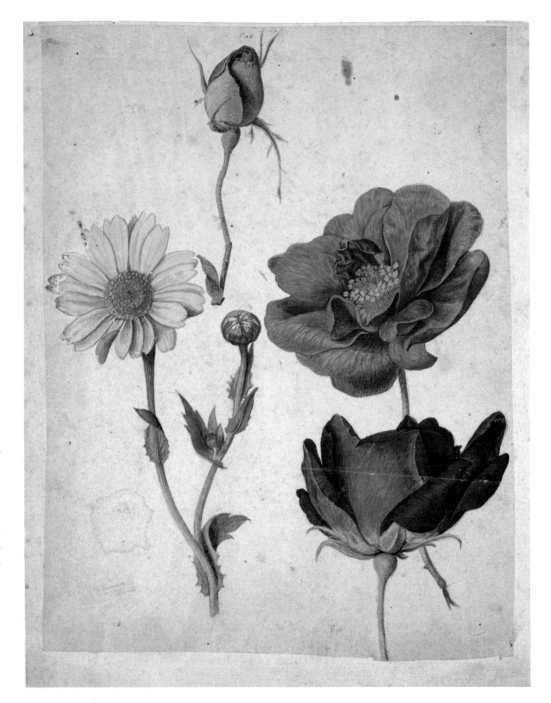

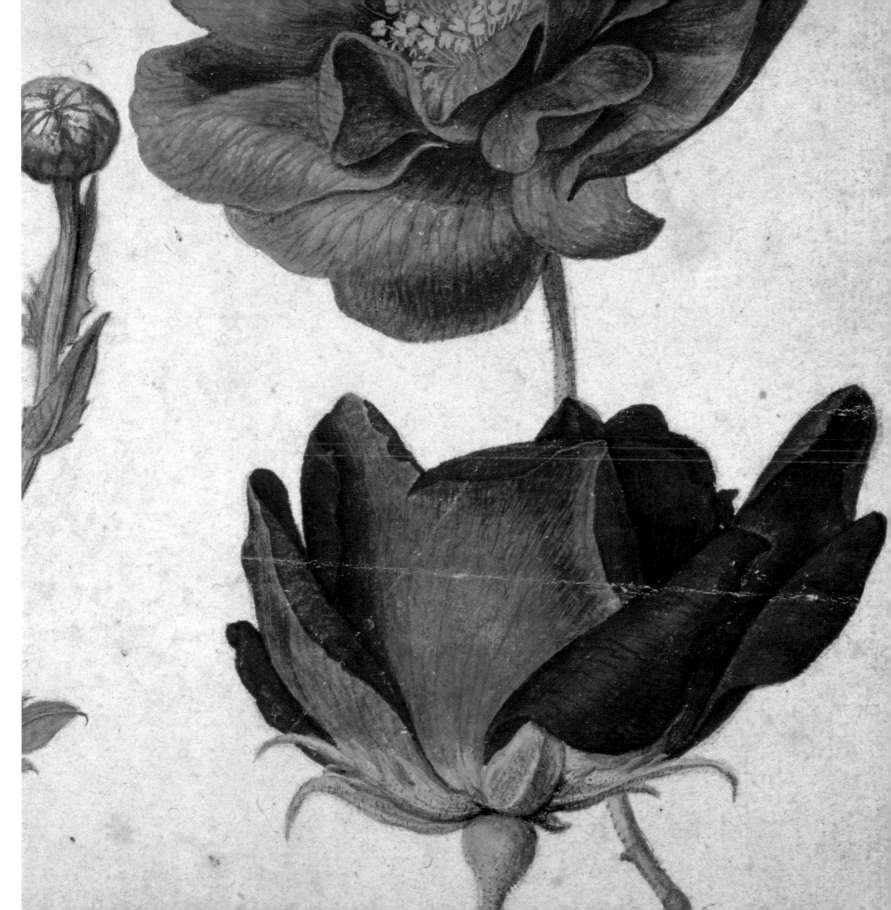

16

Hans Hoffmann

(German, ca. 1530–1591/92)

Flowers and Beetles

1582

Gouache with white chalk over black
chalk on vellum

32.1 x 38.7 cm (12⅝ x 15¼ in.)

J. Paul Getty Museum, 87.GG.98

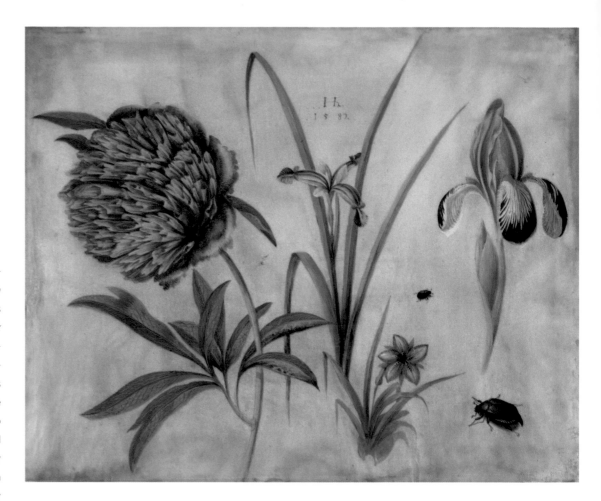

THE USE OF *VELLUM*, the deliberate *mise-
en-page* of this ensemble, and the *monogram*
and date at the center all suggest that this
drawing was made as an *independent work*
of art, and indeed it is documented as hang-
ing framed in the house of Hoffmann's im-
portant *patron* Paulus von Praun. Vellum was
a precious material that had fallen into disuse
by this date (paper was cheaper and easier to
work with), and Hoffmann probably selected
it for the luxury it represented. His minutely
studied representations in *gouache* include a
peony, *iris graminia*, *iris germanica*, possibly
an amaryllis, a may beetle, and a june bug.
The breathtaking naturalism with which he
conveyed these flowers and insects follows
the example of Albrecht Dürer, the great Ger-
man artist whose *style* and work Hoffmann
famously imitated.

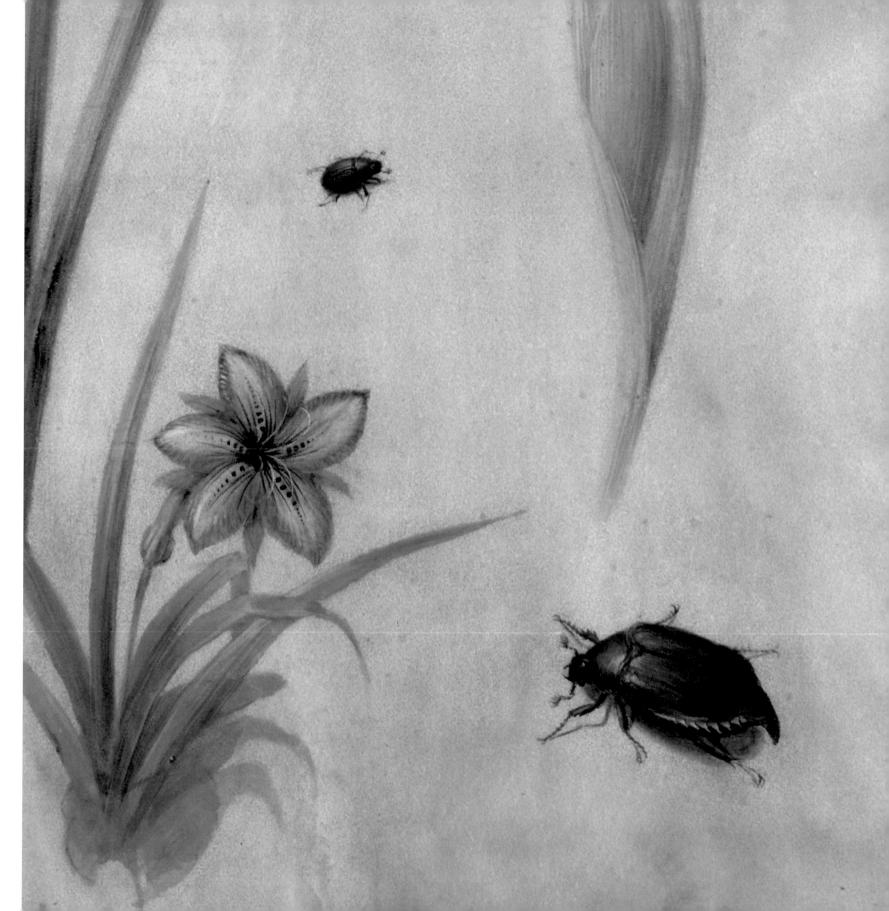

17

Annibale Carracci (Italian, 1560–1609)

An Angel Playing the Violin

1585
Red chalk
16.4 x 20 cm (6½ x 7⅞ in.)
British Museum, 1895,0915.723

NOTABLE FOR ITS DRAMATIC pose and ex-
traordinary handling of light, this drawing is a
preparatory study for the figure of an angel
in Carracci's altarpiece *The Baptism of Christ*
in the church of San Gregorio, Bologna. The
dramatically *foreshortened* pose—with the
elbow seemingly pushing out of the paper—
reflects the fact that the angel is seen from
below in the painting. Touches of *red chalk*
on the top of the upper arm convey the
rounding of the bicep; the figure is lit from
above left, and the underside of the arm sub-
tly shows light reflected from below. A few
simple strokes of chalk indicate the lost pro-
file of the face, finely judged to hint at the
features while showing the recession of the
head in space.

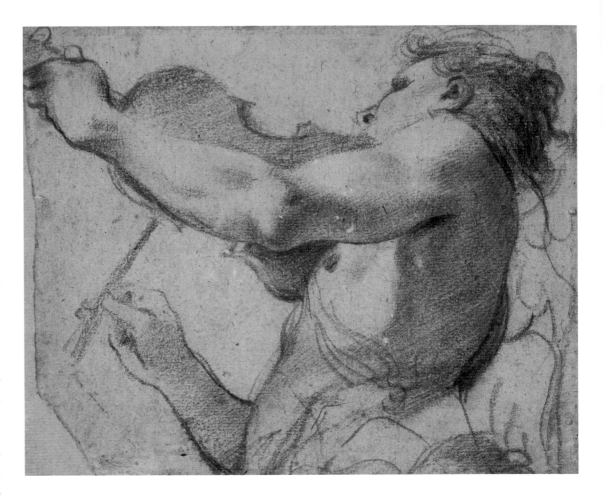

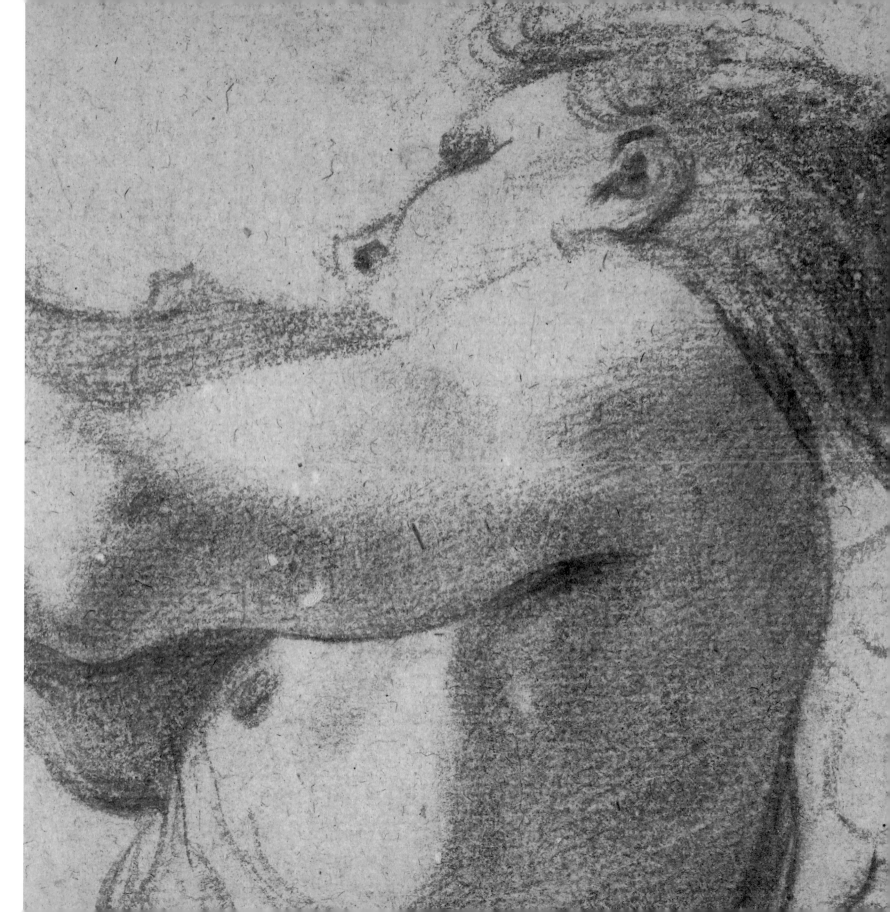

18

Federico Barocci (Italian, ca. 1535–1612)

Head of a Boy

Ca. 1586–89
Black, red, white, and pink chalk on
blue paper
24.9 x 17.6 cm (9 ¹³⁄₁₆ x 6 ¹⁵⁄₁₆ in.)
J. Paul Getty Museum, 94.GB.35

FEDERICO BAROCCI WAS a pioneer in the
use of *pastel* chalks, making his own sticks,
and creating numerous colored sketches
of heads and faces in preparation for his
large-scale oil paintings. Here he studied a
child's face in *foreshortening*, using a light
pink chalk—often broadly rubbed on to the
blue paper—for the areas of the face caught
by the light. Lines and points of intense *red
chalk*, perhaps moistened for extra richness,
highlight the mouth and eyes. *Black chalk* is
used to anchor the outline of the head, but
little attention is given to the hair.

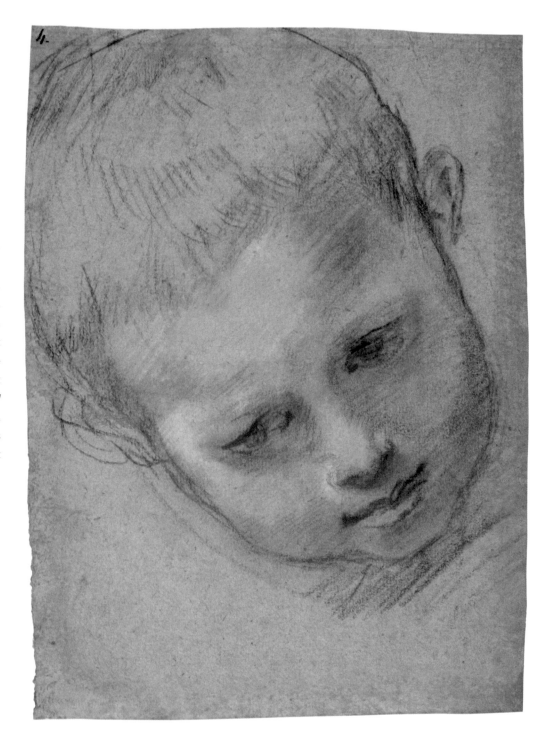

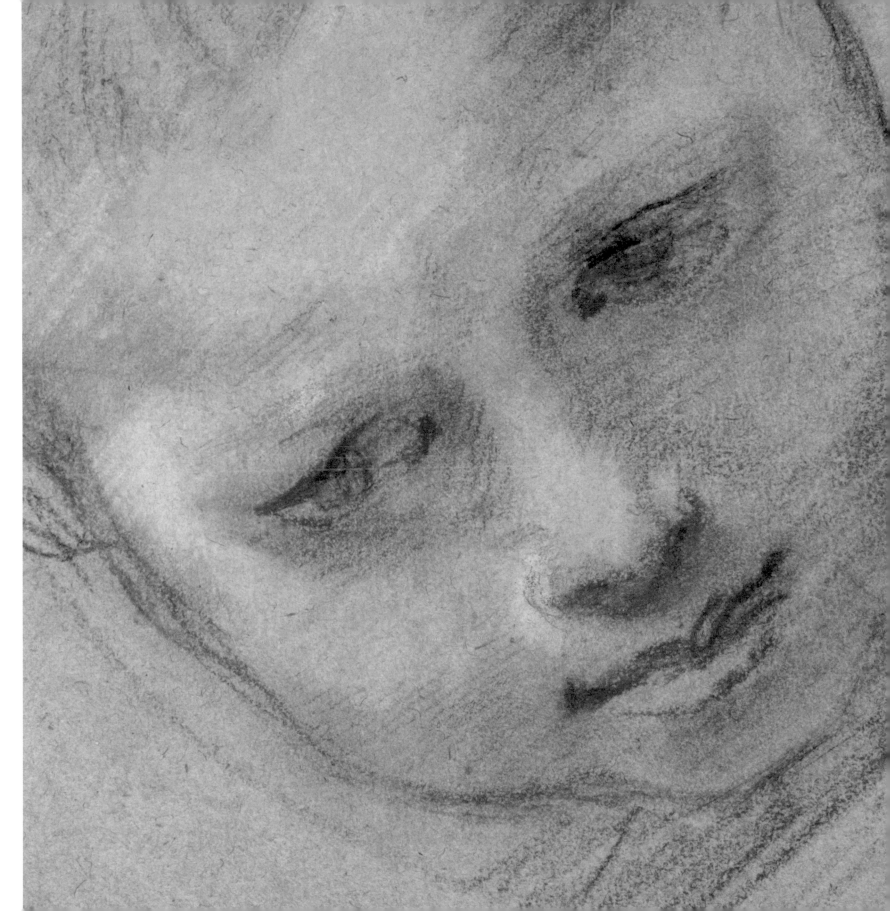

19

Anthony van Dyck (Flemish, 1599–1641)

The Entombment

1617–18
Black chalk; pen and brown ink; brown,
reddish, and greenish washes; red chalk,
and white gouache heightening
25.4 x 21.8 cm (10 x 8⅝ in.)
J. Paul Getty Museum, 85.GG.97

IN THIS DRAMATIC *compositional study*,
Van Dyck plans the placement of figures
for a painting of the Entombment of Christ
(not now known: perhaps never produced
or else lost or destroyed). While *black chalk
underdrawing* and *quill pen* lines were used
initially to create the basis of the composi-
tion, the thick brown *wash* applied with a
brush renders dark shadows which bring
forward the white of the paper as a strong
highlight. In areas of the background and
elsewhere (most visible in the drapery on the
right), the artist skillfully used the *starved
brush* technique to create lines with less den-
sity. He also marked the boundaries of the
composition with brushed *framing lines*. At
lower right is the *collector's mark* of Nicolaes
Flinck (1646–1723), son of the painter Gov-
aert Flinck (see no. 23).

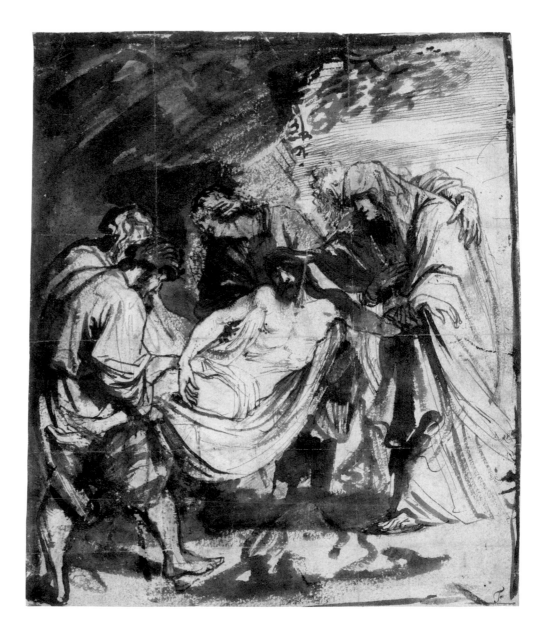

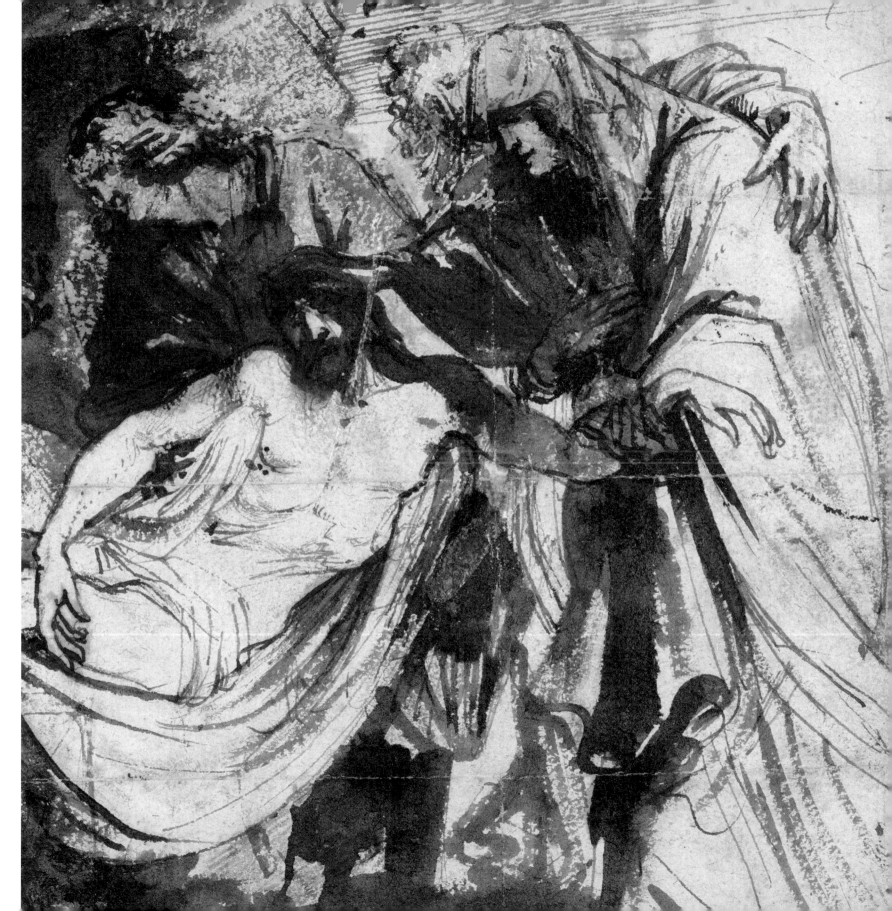

20

**Guercino (Giovanni Francesco Barbieri)
(Italian, 1591–1666)**

A Theatrical Performance in the Open Air

Ca. 1620
Pen and brown ink, brush with brown
wash, over black chalk
35.8 x 46.2 cm (14⅛ x 18⅜ in.)
British Museum, 1937,1008.1

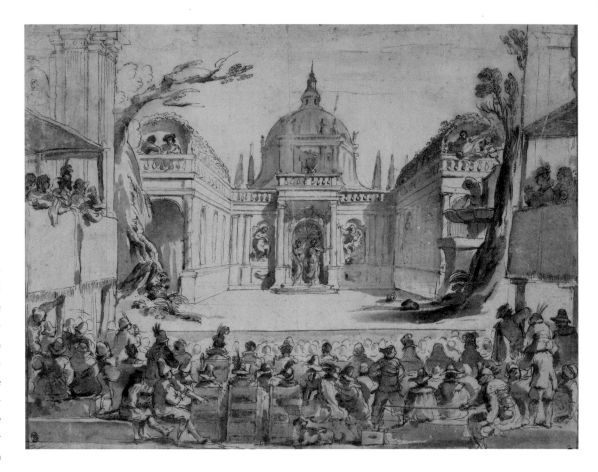

KNOWN FOR HIS INTEREST in sketching re-
alistic scenes of everyday life, the cross-eyed
artist *il Guercino* (Italian for "The Squinter")
here delights in depicting the crowd at a the-
ater. Seen from behind, the figures display a
variety of clothes and headgear, and the tex-
tures of feathers and forms of floppy hats are
emphasized. Guercino uses an adept combi-
nation of *quill pen* lines and patches of *wash*
applied with a brush for the composition. For
example, the man at right carrying a child on
his shoulders is composed with a few pen
lines but given solidity and weight by pools
of wash, which round the figure and darken
to show the shadow under his arm.

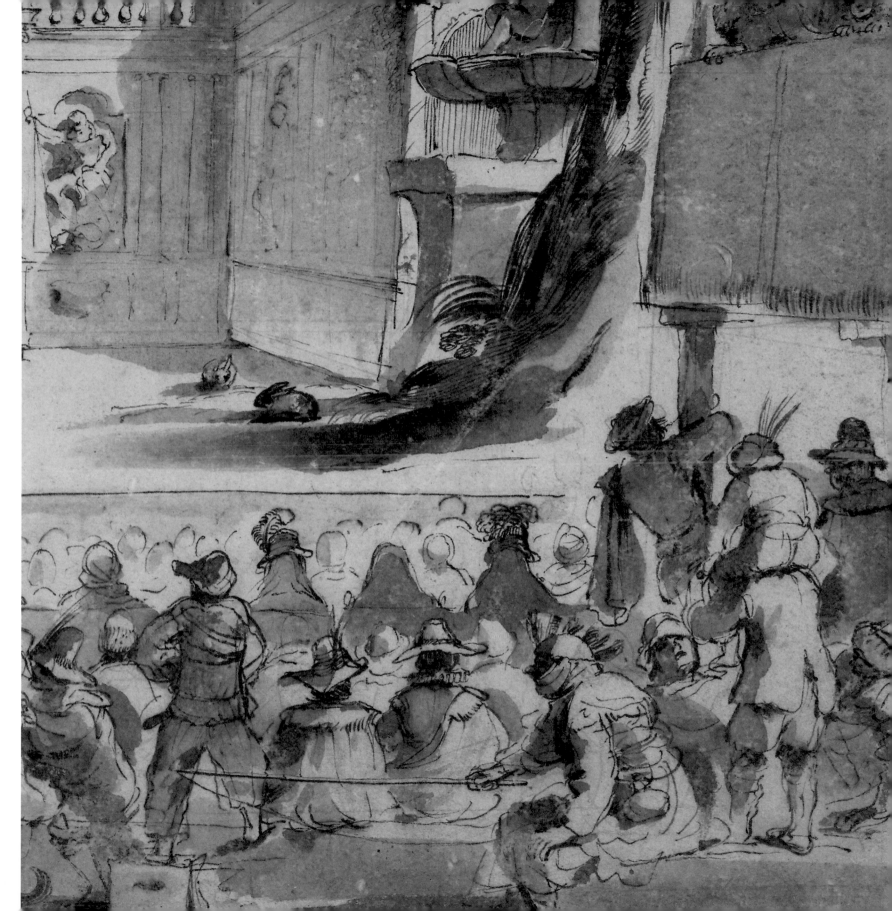

21

Abraham Bloemaert (Dutch, 1564–1651)

*Four Studies of Hands and a Counterproof
of a Kneeling Young Man*

1620s
Red chalk heightened with white gouache
25.1 x 17.1 cm (9⅞ x 6¾ in.)
J. Paul Getty Museum, 83.GB.375 verso

THE PAINTER AND PRINTMAKER Abraham
Bloemaert used the *counterproof* technique
to produce this drawing of a kneeling youth.
The image was transferred by dampening
this sheet when it was blank and pressing
it against the original drawing (of a kneel-
ing youth, location unknown). Bloemaert
has then drawn studies of hands directly on
the sheet around the counterproofed image.
That the figure is a counterproof is evident
from the fact that the direction of the *hatch-
ing* goes from top left to bottom right, the re-
verse of that in the study of a hand at the top,
which the artist drew directly. The image of
the kneeling youth is also blurred, and the red
chalk has a less intense color. For Bloemaert,
making the counterproof was easier than
drawing the figure in reverse from scratch,
and seeing the figure reversed allowed him to
estimate its effectiveness in a print or posed
as such in a painting.

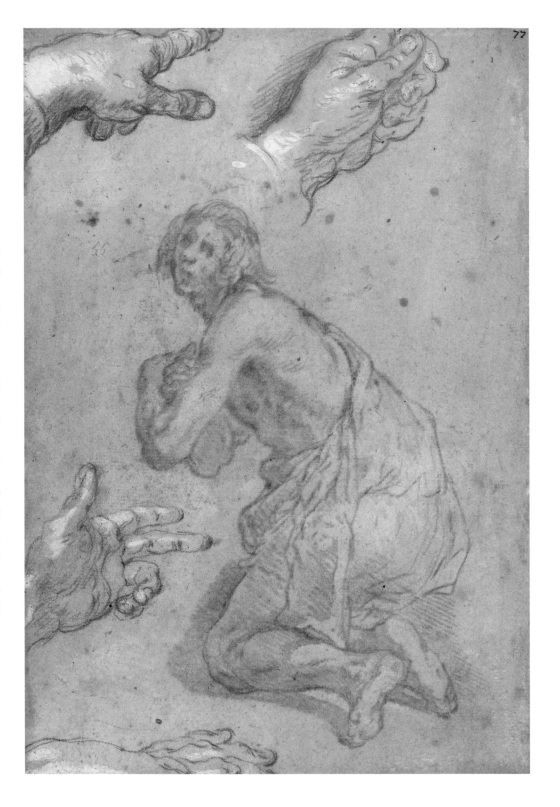

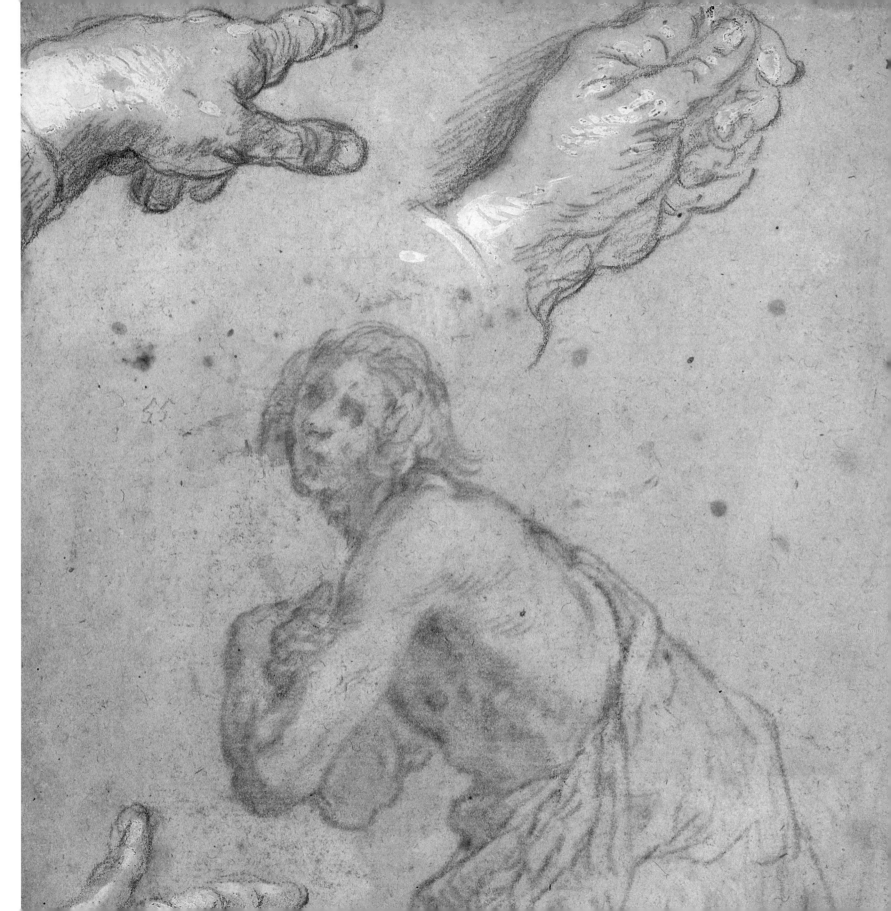

22

Rembrandt van Rijn (Dutch, 1606–1669)

*Joseph in Prison Interpreting the Dreams
of Pharaoh's Baker and Butler*

Ca. 1639
Pen and brown ink on light brown prepared
paper; the figure of Joseph is on an added,
irregularly cut sheet (Rembrandt probably
cut up another drawing and pasted a part
here to create this new composition); fram-
ing line added by a later collector
20 x 18.7 cm (7⅞ x 7⅜ in.)
J. Paul Getty Museum, 95.GA.18

REMBRANDT ROUTINELY MADE drawings
such as this to study the interaction between
characters in a particular scene, specifically
their expressions. Here he treats a biblical
scene (Genesis 40: 1–20) in which the impris-
oned Joseph interprets the dreams of two
fellow captives: the butler (at right), who is
told that he will be released, and the baker (at
center), who learns that he will be sentenced
to death. A *subsidiary study* of the baker,
drawn immediately above, shows him with a
more subtle expression of shock and recoil at
hearing his fate.

Rembrandt has a distinctive cal-
ligraphic *style*; his figures are anchored in
space by their heads and feet, the latter just
summarily sketched, with the remainder of
the body rendered through a series of abbre-
viated dancing lines. Human expression and
the psychology of the moment are always
keenly represented, and Rembrandt was ad-
ept at capturing them using very few lines.

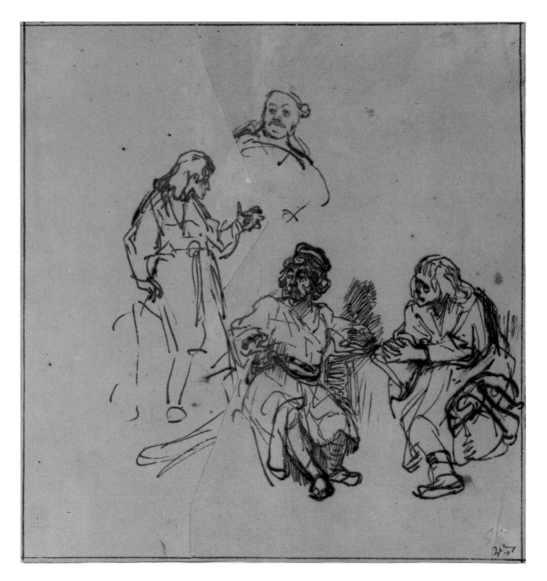

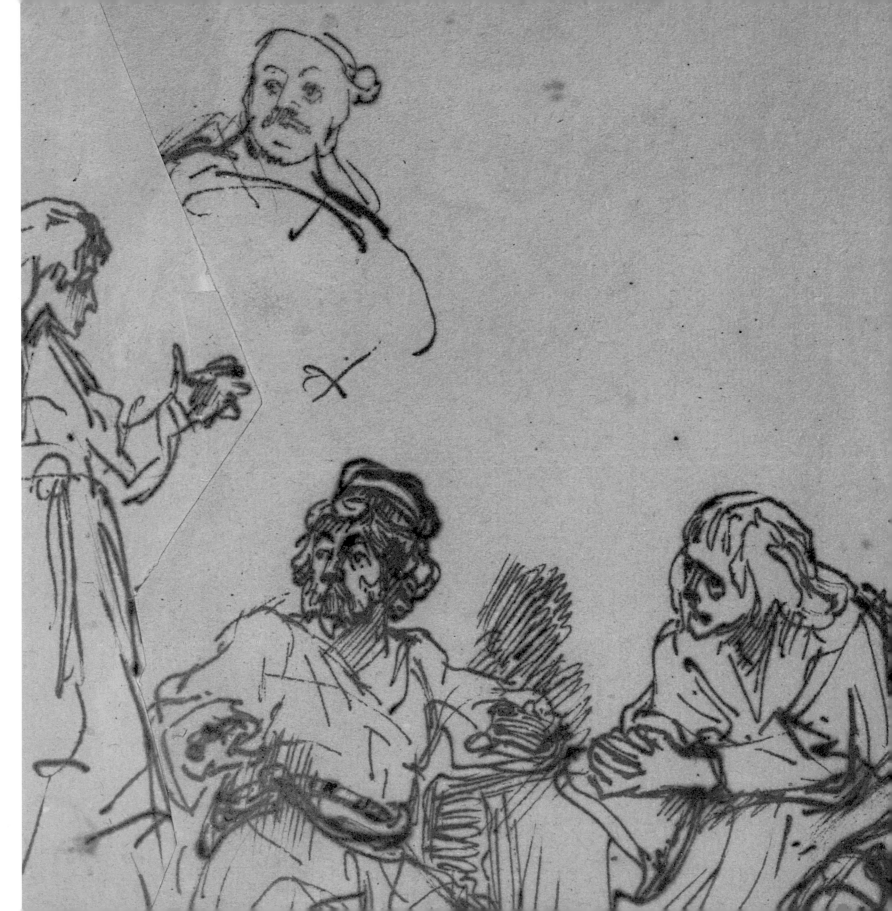

23

Govaert Flinck (Dutch, 1615–1660)

*Joseph in Prison Interpreting the Dreams
of Pharaoh's Baker and Butler*

Ca. 1639
Pen and brown ink, traces of black chalk
11.4 x 13.5 cm (4½ x 5⁵⁄₁₆ in.)
J. Paul Getty Museum, 2007.5

REMBRANDT AND HIS PUPILS often acted
out biblical stories in the studio as exercises
in expression and made drawings of the re-
sults. Here Rembrandt's pupil Govaert Flinck
has sketched the story of Joseph interpret-
ing dreams in prison, a theme also drawn by
Rembrandt at about the same time (see no.
22). Flinck has reversed the scene from that
of Rembrandt, placing Joseph at the right
and the baker and the butler on the left. He
has also made other changes, including add-
ing an architectural background.

Flinck's *style* is clearly indebted to
that of his master, using fluid pen lines to ren-
der the scene, employing carefully placed
touches of brown wash as accents, and offer-
ing abbreviated descriptions of the figures.
Black chalk *underdrawing* is visible beneath
a number of the lines, but the pen is handled
confidently, and Flinck has learned Rem-
brandt's seemingly effortless *foreshortening*,
for example, in Joseph's right arm and hand.

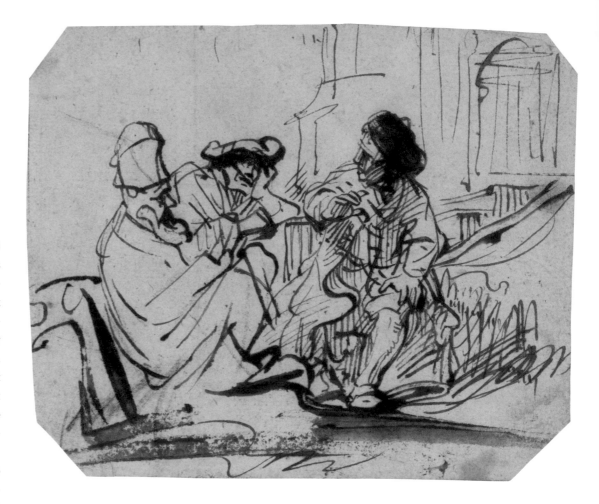

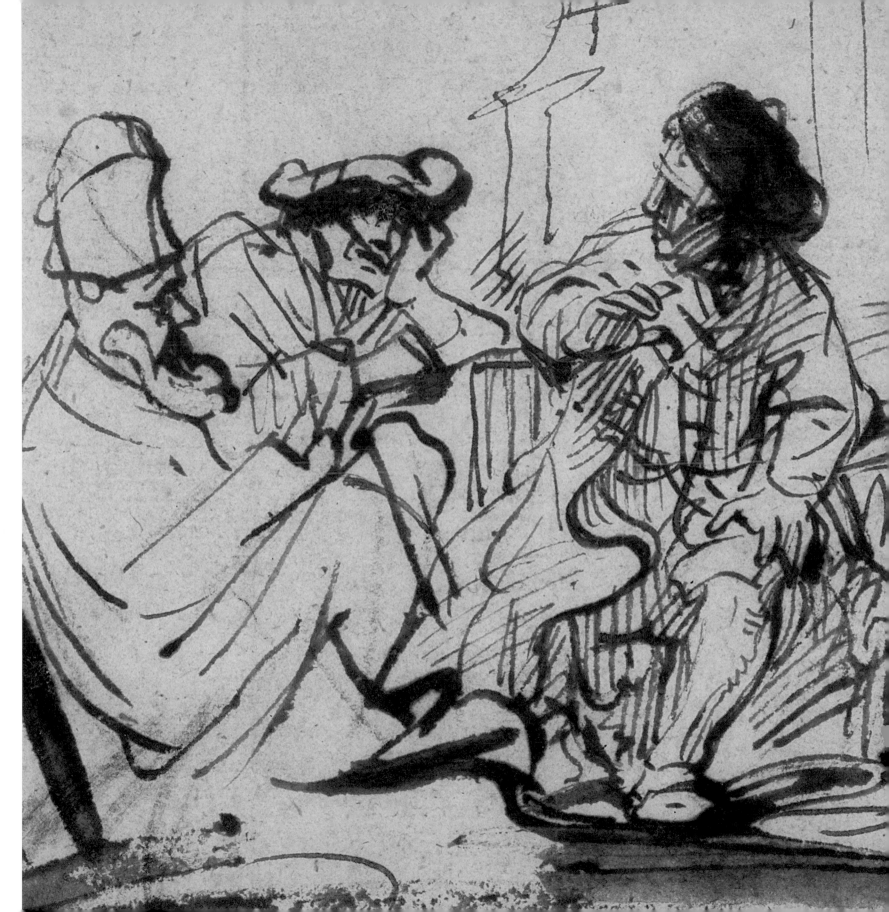

24

Rembrandt van Rijn (Dutch, 1606–1669)

Shah Jahan and Dara Shikoh

Ca. 1654–56
Pen and brown ink and brown wash,
heightened with white gouache on
Japanese paper
21.3 x 17.8 cm (8⅜ x 7 in.)
J. Paul Getty Museum, 85.GA.44

IN THIS DRAWING ON smooth *Japanese paper* Rembrandt has made a *copy* of a contemporary Mogul miniature. The assurance and speed of his draftsmanship has animated the two figures, and the lively penwork is punctuated only by selected application of a light *wash*, which is also used to make a background that locates the figures in space. The shah's beard has been drawn with the point of a brush, producing an effective impression of texture in contrast to the scratchy *quill pen* lines. This drawing is on a *mount* typical of the collector-artist Jonathan Richardson Senior (see no. 30), with a painted gold band surrounding the sheet, several line and wash borders, and an attribution on the lower edge. Richardson's *collector's mark* is at the lower right corner. According to an inventory compiled after his death, Richardson owned no fewer than twenty-five drawings of Indian subjects by Rembrandt. The mark of the collector-artist Thomas Hudson is at lower left.

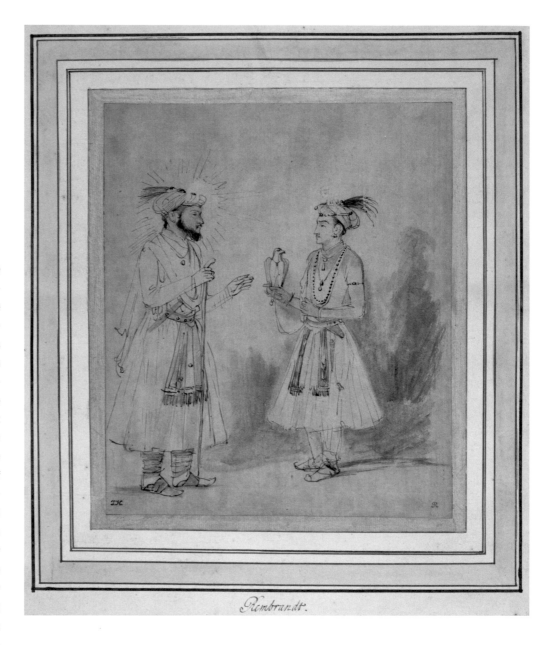

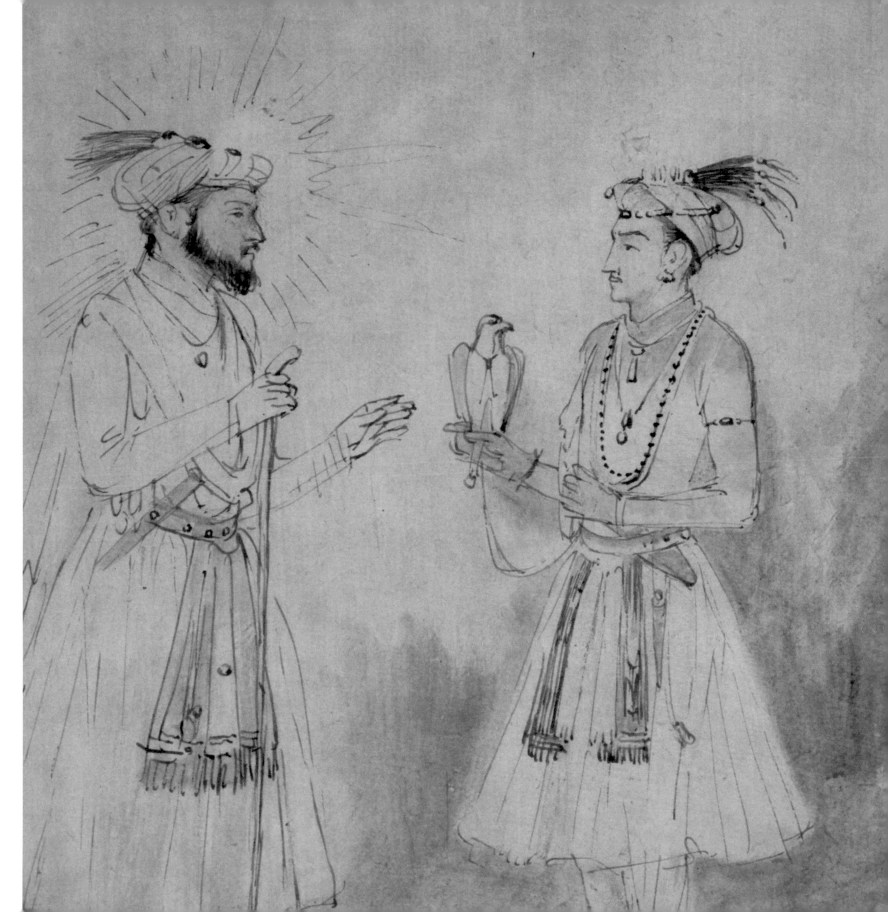

25

Pietro da Cortona (Italian, 1596–1669)

Christ on the Cross with the Virgin Mary,
Mary Magdalene, and Saint John
the Evangelist

Ca. 1661
Pen and brown ink and gray wash over
black chalk, heightened with white
gouache, on light brown paper; squared
in black chalk; the oval only reinforced in
red chalk
40.3 x 26.5 cm (15⅞ x 10⁷⁄₁₆ in.)
J. Paul Getty Museum, 92.GB.79

PIETRO DA CORTONA USED this *modello* as
the basis for two separate oil paintings—one
oval and one rectangular—and he has drawn
two *framing lines* (the oval in *red chalk*, the
rectangle in brown ink) to serve his purposes.
Although the initial composition was drawn
in pen and brown ink over *underdrawing* in
black chalk, the sense of *high finish* is given
by the abundant use of *gouache*. The artist
has used gray *wash*, gray gouache, and thick-
ly applied *white heightening* in combination
to produce the dramatically windblown ba-
roque drapery of Saint John the Evangelist.
Squaring in black chalk has been applied to
the sheet to enable the easy transfer of the
design onto the surface to be painted.

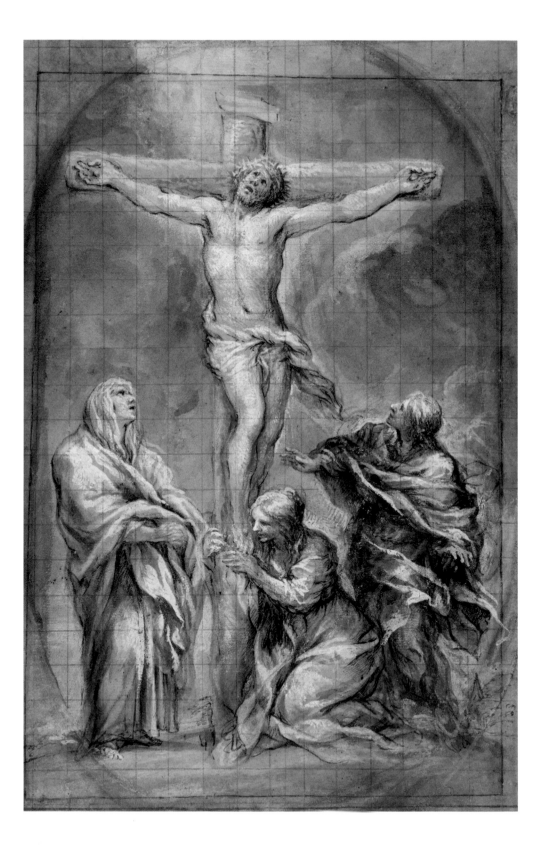

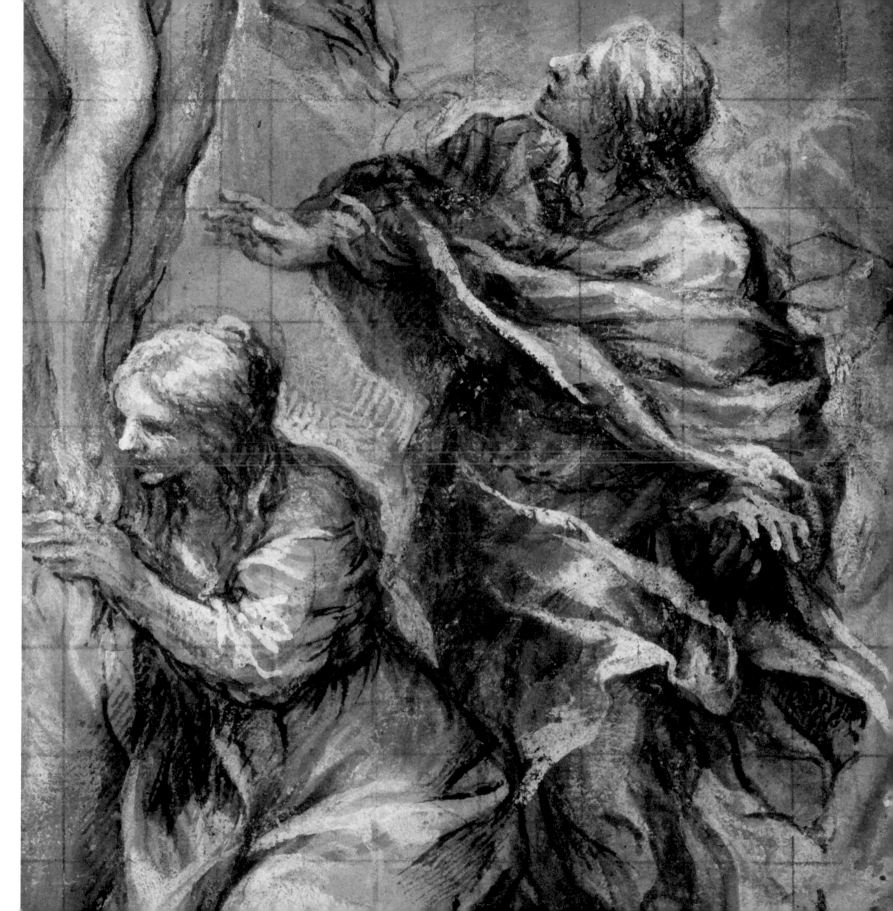

26

Adriaen van Ostade (Dutch, 1610–1685)

Village Scene with Figures outside
a Cottage

1673
Pen and brown ink, watercolor, gum
arabic, and gouache
26 x 22.1 cm (10¼ x 8⅝ in.)
British Museum, 1895,0915.1239

OUTSIDE A RAMSHACKLE cottage, children
inflate a pig's bladder, either for use as a ball
or to be amused by the sound it produced
as it deflated. This is one of a number of nar-
rative details that supplement the carefully
observed setting in *watercolor*: the mottled
brickwork, wooden shed rotting at the base,
and bunch of carrots. The opaque nature of
the blue *gouache* used in the little girl's top
can be seen as it covers the ink line on her left
shoulder, and her basket is created by flecks
of brown paint over a blotchy brown wash.

　　Van Ostade created numerous col-
ored, finished drawings such as this for sale
to collectors, in addition to the oil paintings
he made. His lively attention to detail made
them models for centuries of narrative art
and book illustration.

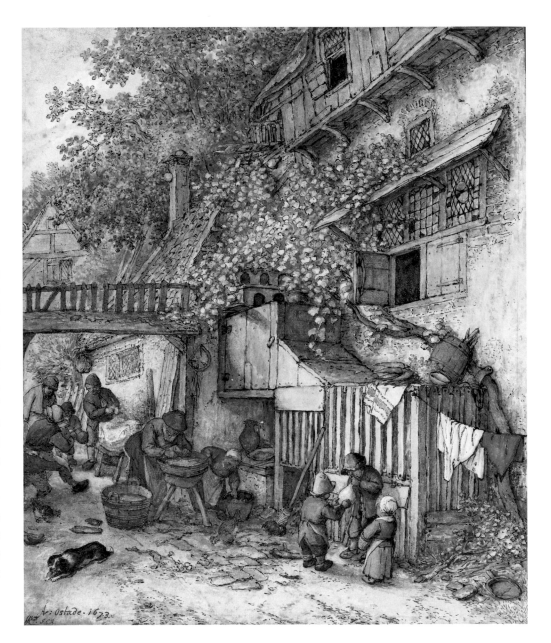

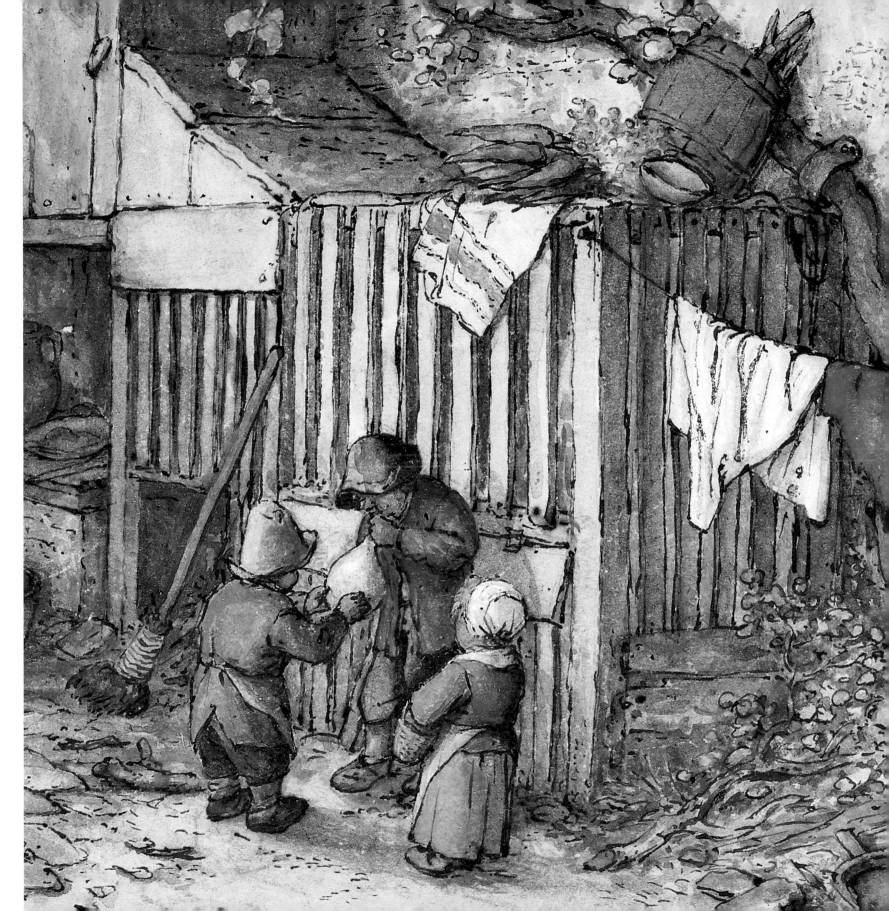

27

Claude Lorrain (French, 1604–1682)

Coast Scene with Perseus and the Origin of Coral

1674
Pen and brown ink, brush with gray and blue washes, heightened with white, on blue paper
19.5 x 25.4 cm (7⅝ x 10 in.)
British Museum, 1957,1214.190

TO PROTECT HIS WORK against forgers and serve as a record of the paintings he had made, Claude kept a book of drawings of their compositions called the *Liber Veritatis* (The Book of Truth). In this one, rendered on a cool blue paper, Claude used a thick white *gouache* applied with a brush for the dazzling sun and sunlight that catches the top of the clouds. A brushed blue *wash* supplements the color of the paper for the distant hills and the darker water, and rapid work in pen and brown ink creates the dramatic silhouetted effect of leaves on the left. *Iron gall ink damage* is evident in the darkened lines of the tree trunk.

Claude's famous landscape compositions were not intended as reflections or depictions of reality but as idealized, balanced backdrops suitable for the gods and mythological figures shown within them.

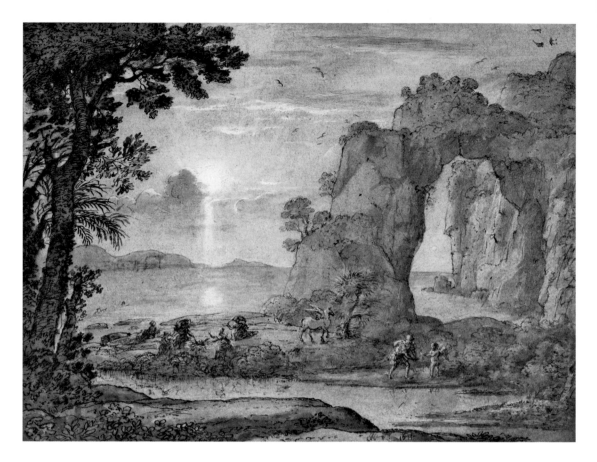

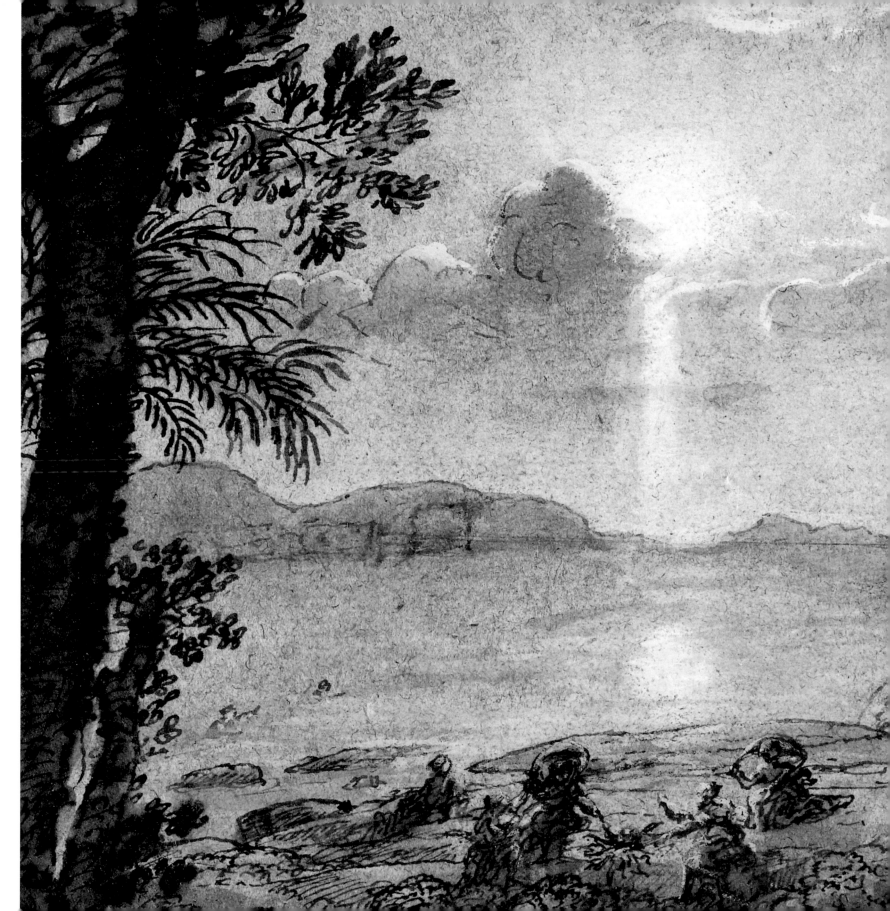

28

**Jean-Antoine Watteau
(French, 1684–1721)**

Studies of Three Women

Ca. 1716–17
Red, black, and white chalk
26.8 x 32.7 cm (10⁹⁄₁₆ x 12⁷⁄₈ in.)
J. Paul Getty Museum, 86.GB.596

WATTEAU MADE DOZENS of drawings like
this, either from lay figures (draped wooden
dolls) or from life, mounted them in albums,
and used them as a repertoire of figures for
his paintings. Generally, the sheets contain
several studies, some more finished than
others, and all arranged with a careful *mise-
en-page*. In this case the central figure is the
most highly worked, with an intricate use of
black and *red chalks*, highlighted with a few
accents of white chalk. Watteau utilized black
and red chalks separately for specific parts
of the design and employed both in the hair.
Almost synonymous with this *trois crayons*
(three crayons) technique, Watteau usually
selected a fibrous tan paper that set off the
rich powdery chalks.

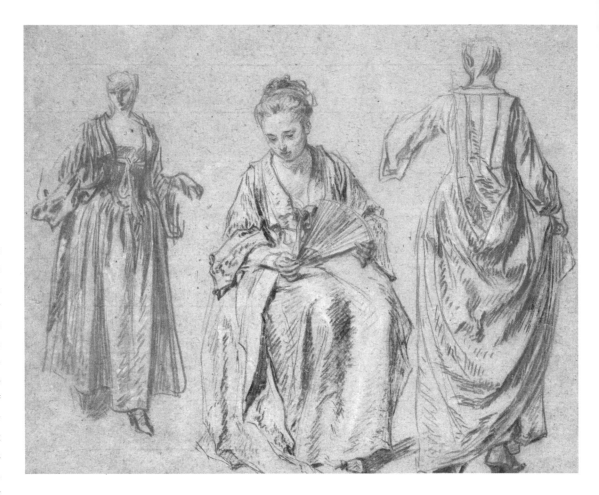

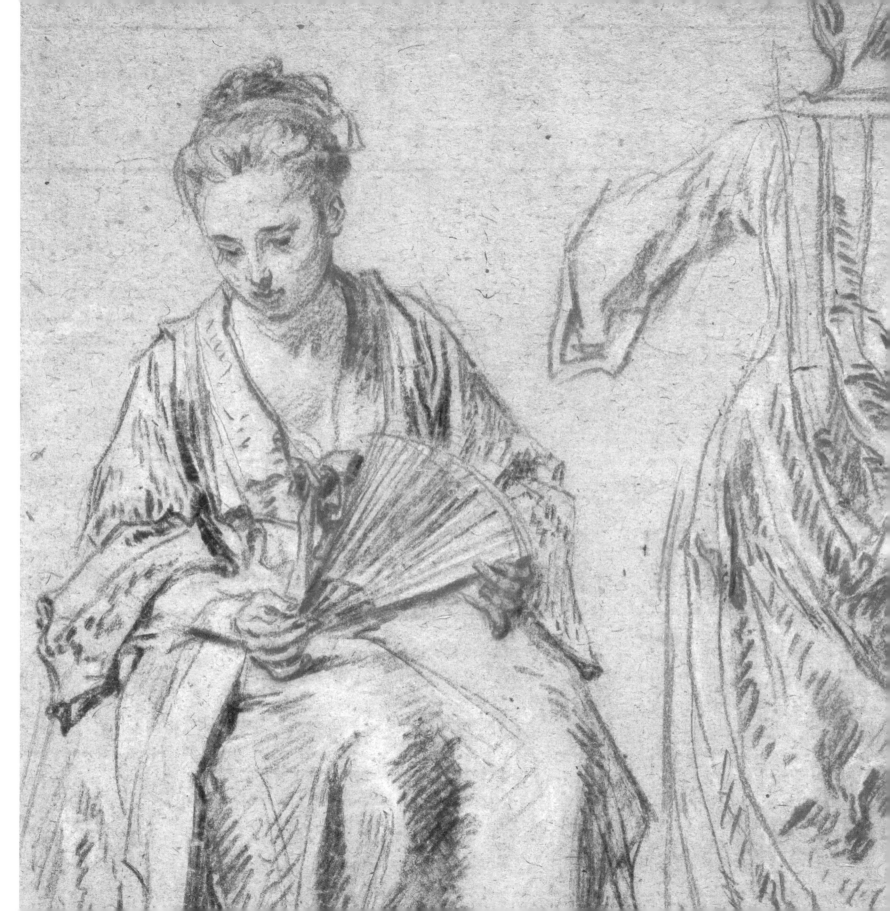

29

Rosalba Carriera (Italian, 1675–1757)

A Muse

Mid-1720s
Pastel on laid blue paper
31 x 26 cm (12³⁄₁₆ x 10¼ in.)
J. Paul Getty Museum, 2003.17

USING A WIDE VARIETY of pastel colors, Carriera created this idealized representation of a muse as an *independent work* of art. The exquisite *high finish* was deliberately used to make the drawing feel like a small finished painting, while the powdery pastel medium gives the work an appealing softness and immediacy. Pastelists often used *blue paper* as a support; it represented a vibrantly colorful mid-tone that could be easily modified by the pastel colors.

A successful woman in a profession dominated mainly by men, Carriera became so famous that her pastels were not only bought by visitors to her native Venice but also requested (and sent by mail) to admiring patrons all across Europe.

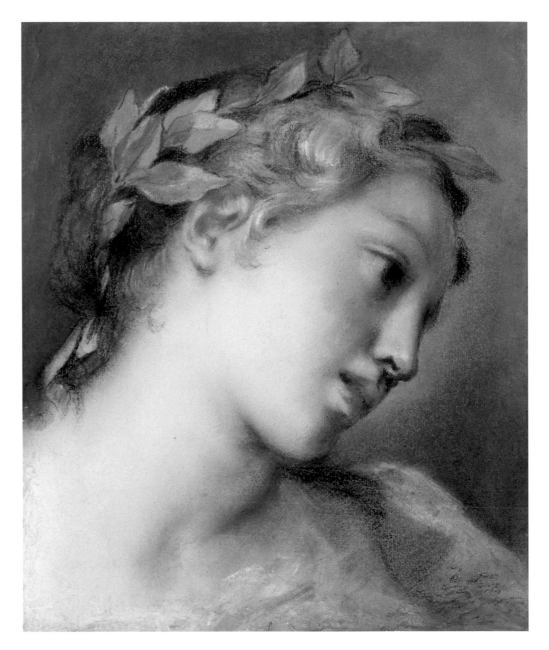

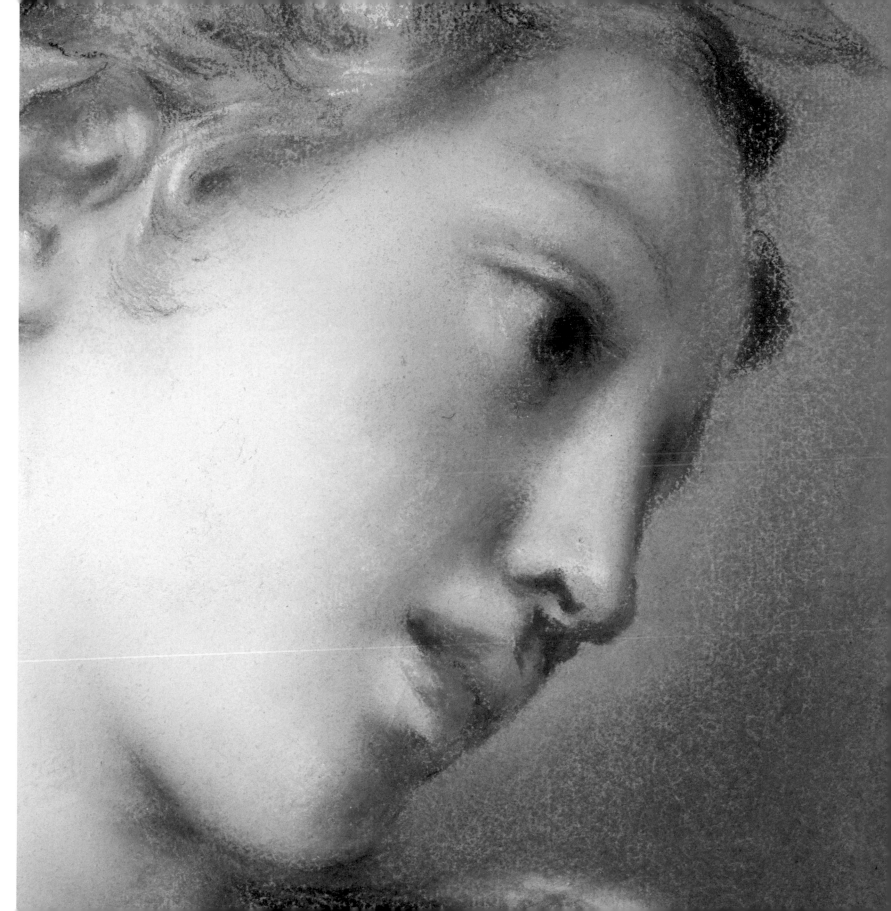

30

**Jonathan Richardson Senior
(British, 1667–1745)**

Self-Portrait

1728
Black chalk, heightened with white chalk,
on blue paper
44.2 x 29.5 cm (17⅜ x 11⅝ in.)
British Museum, 1902,0822.44

FOR AN ARTIST WISHING to draw, there
can be no more patient or faithful a model
than the one found in the mirror. Jonathan
Richardson was a noted painter, theorist, and
collector who drew himself dozens of times
throughout his life; here he was sixty-one
years old (he *dated* the drawing "24 June
1728" at lower right). Artists were themselves
the earliest and most enthusiastic collec-
tors of drawings, and Richardson amassed
a huge collection, which were stamped with
his *collector's mark*, a small "JR" monogram
(visible here at lower right and on no. 24).
In this large (almost life-size) self-portrait
he used the combination of *black chalk* and
blue paper beloved of Venetian artists. It is
a rapid sketch, using the "tooth" of the *laid
paper* to hold broad strokes made with black
chalk and *white heightening* on the forehead,
around the eye, and down the nose.

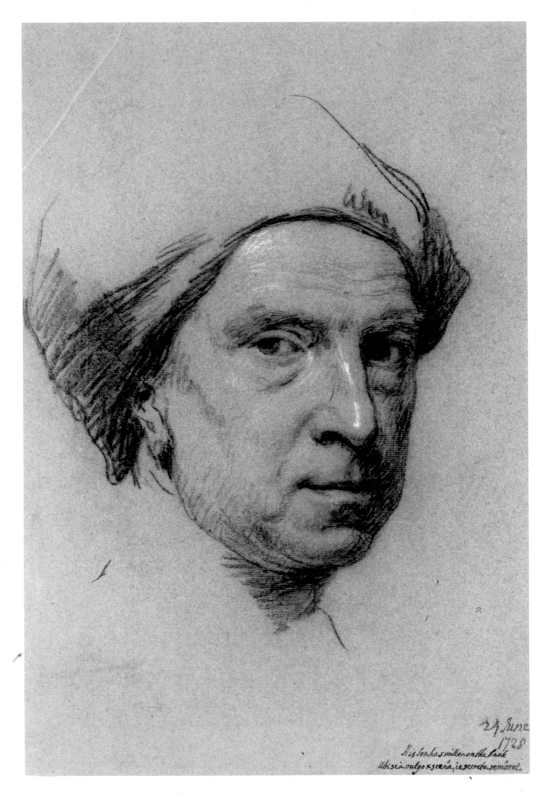

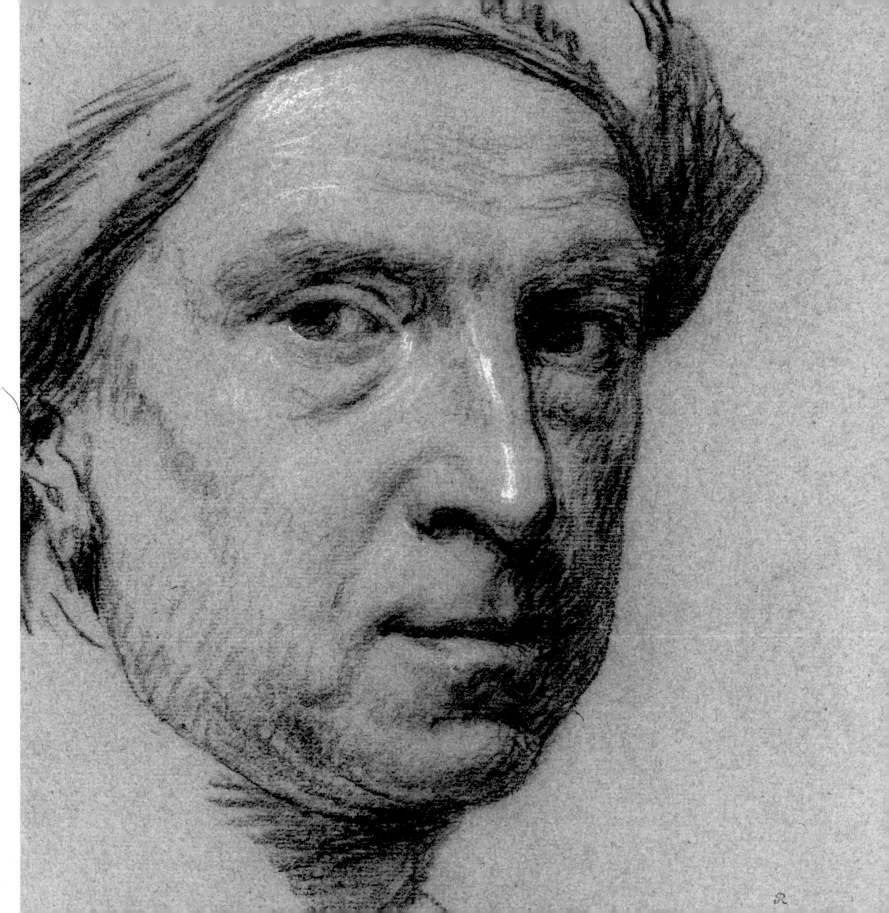

31

Giovanni Battista Tiepolo
(Italian, 1696–1770)

Head of a Man Looking Up

Ca. 1750–60
Red and white chalk on blue paper
21.8 x 15.2 cm (8⅝ x 6 in.)
J. Paul Getty Museum, 2002.31

A BRAVURA ZIGZAG OF *red chalk* on the man's nose demonstrates the confidence with which Giovanni Battista Tiepolo (the principal of a famous family of Venetian artists) approached this study from life. The model, with a distinctive gap between his teeth, is the subject of a number of other drawings by Tiepolo and was likely an assistant in his studio; this particular study was made prior to depicting a similarly posed figure in a fresco. Warm red chalk is used in conjunction with strokes of white on a *blue paper* (now faded to blue-gray), displaying the eighteenth-century Venetian love of colorful effects.

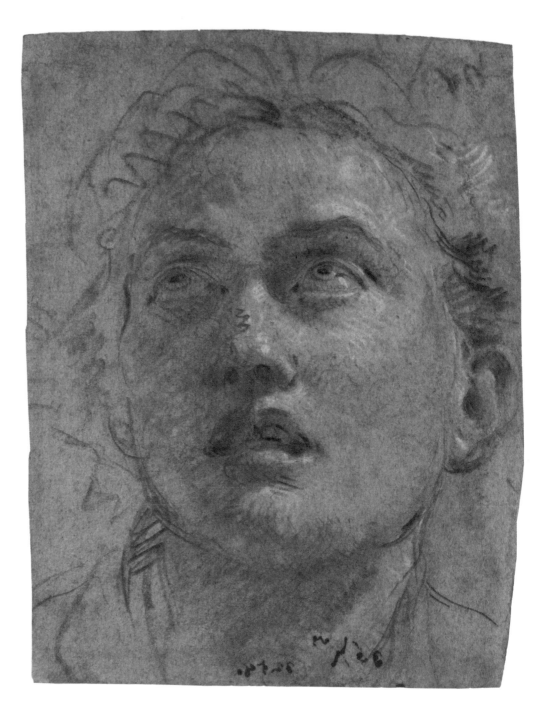

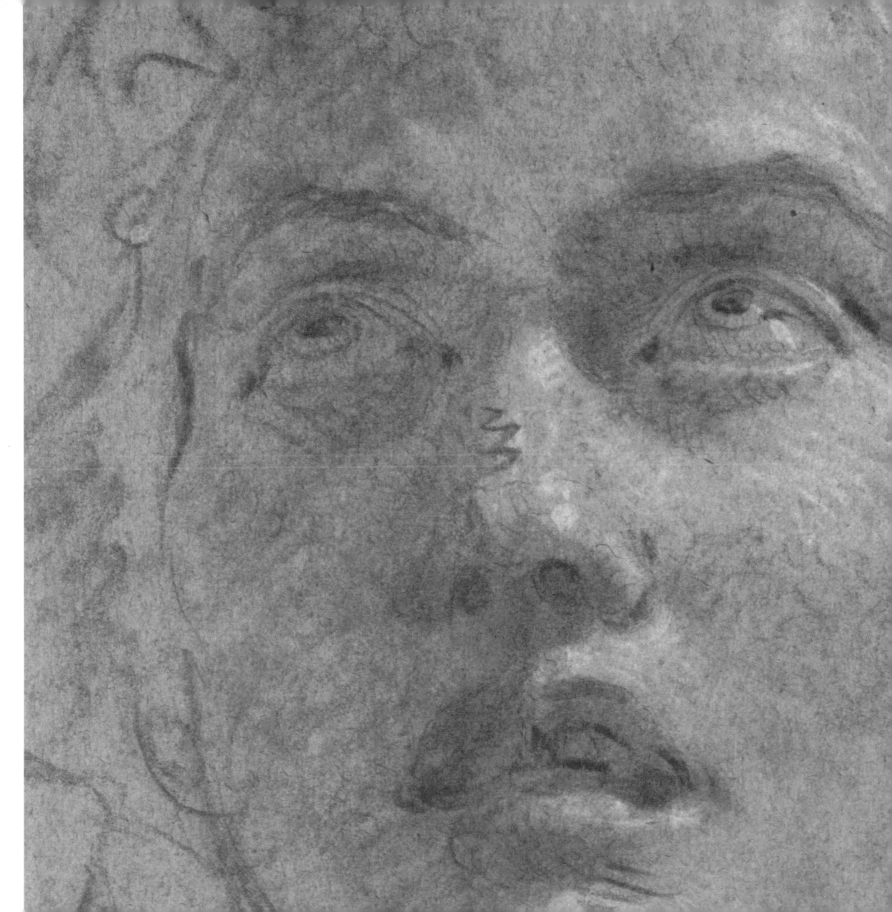

32

**Giovanni Domenico Tiepolo
(Italian, 1727–1804)**

Punchinello Is Helped to a Chair

Ca. 1791
Pen and brown ink, brush with bistre
wash, and black chalk
35.4 x 47 cm (13¹⁵⁄₁₆ x 18½ in.)
J. Paul Getty Museum, 84.GG.10

GIOVANNI DOMENICO TIEPOLO, the son of
Giovanni Battista (see no. 31), here created a
drawing of outstanding luminosity with his
combination of media and technique. The
golden *bistre wash* that covers most of the
sheet has a warm and radiant tone, while
Giovanni Domenico has deliberately left *re-
serves* of white paper to act as highlights.
Particles of the soot from which the bistre
was made are visible on the "wall" above the
heads of the principal characters. The draw-
ing is one of over a hundred sheets depict-
ing the adventures of the commedia dell'arte
character Punchinello, from whom the
modern-day Mr. Punch is derived. Here he
is helped to a chair, perhaps after a night of
debauchery. The drawings were perhaps cre-
ated as designs for prints but could also have
been intended for the amusement of the art-
ist's friends and family. The sheet is *signed* at
the lower right.

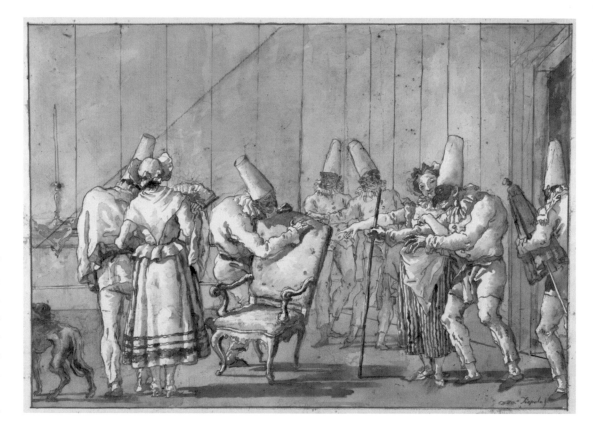

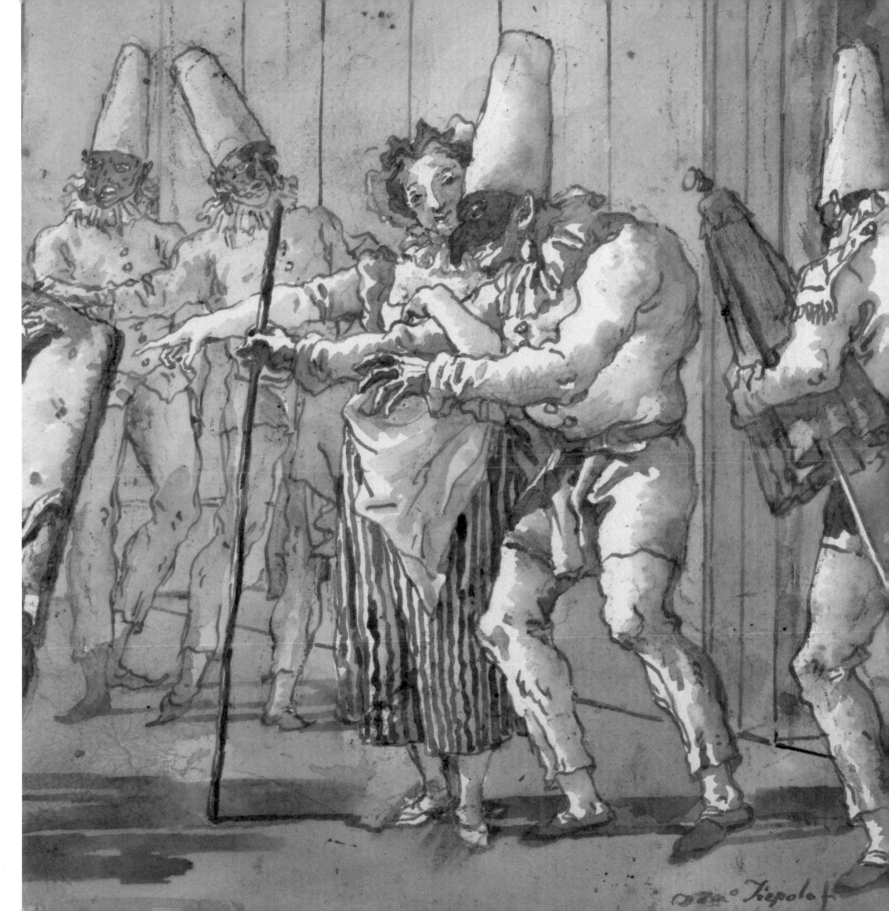

33

Jacques-Louis David
(French, 1748–1825)

Portrait of André-Antoine Bernard (1751–
1819), called Bernard de Saintes

1795
Pen and brush with india ink and gray
wash, heightened with white gouache,
over graphite
Diam.: 18.1 cm (7⅛ in.)
J. Paul Getty Museum, 95.GB.37

AN *INSCRIPTION* ON THE reverse records
that this tense, stark portrait was drawn on
July 24, 1795, during the French Revolution,
when the artist and the sitter were impris-
oned together for their political beliefs. It
adopts the profile view and circular format
of ancient coins and medals (see also no. 3).
David used thick black *india ink* in the hat,
hair, and shadows as the basis for a strongly
realistic depiction of his sitter, whose facial
features and coat are rendered in somber
and carefully modulated gray *washes*. Given
the preliminary graphite *underdrawing*, mini-
mal use has been made of the pen, and the
effects are created almost entirely through
washes and strokes with the point of the
brush. David's portrait of Bernard de Saintes
is among the most evocative images of the
Reign of Terror.

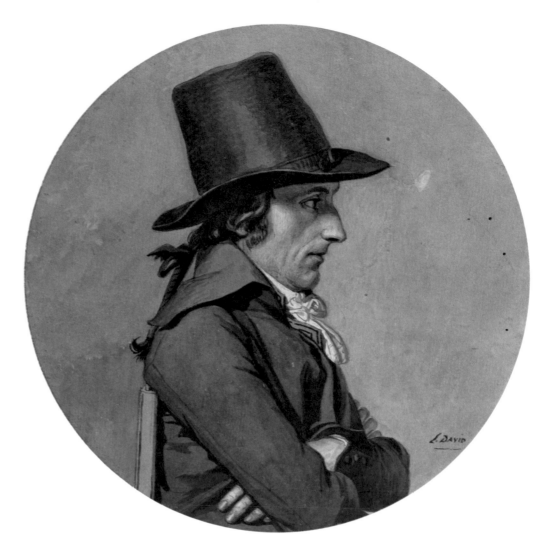

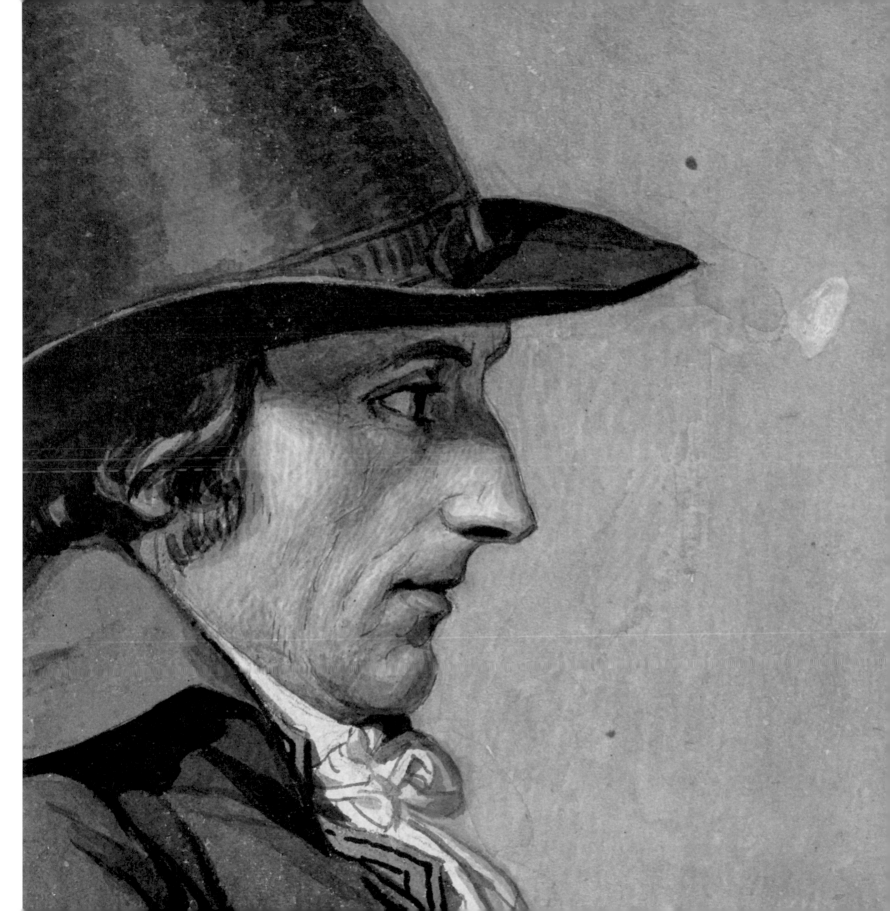

34

Théodore Géricault (French, 1791–1824)

Studies of Horses

1813–14

Graphite

21 x 27.9 cm (8¼ x 11 in.)

J. Paul Getty Museum, 88.GD.46

CONTAINING JUMBLED STUDIES of horses drawn to different scales, this sheet was probably made while Géricault was preparing to paint a number of canvases of Polish horsemen. Géricault used the versatile and rapid *graphite* medium to capture the energy and vitality of the moving steeds. Long gray lines render the flowing mane of the central creature, while the artist has pressed harder with the graphite to create the darker outline of the profile and the intensity of the nostril and eye socket. The modeling within the horse's head, rendered by soft *hatching*, is the result of a much lighter pressure of the pencil. The various studies are dominated by a fluid dynamism; Géricault was passionate about horses.

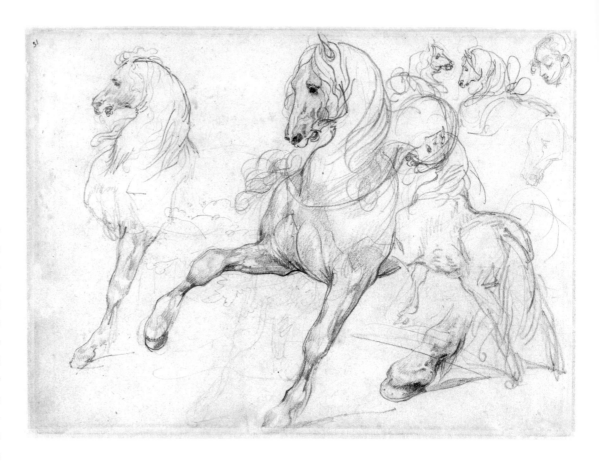

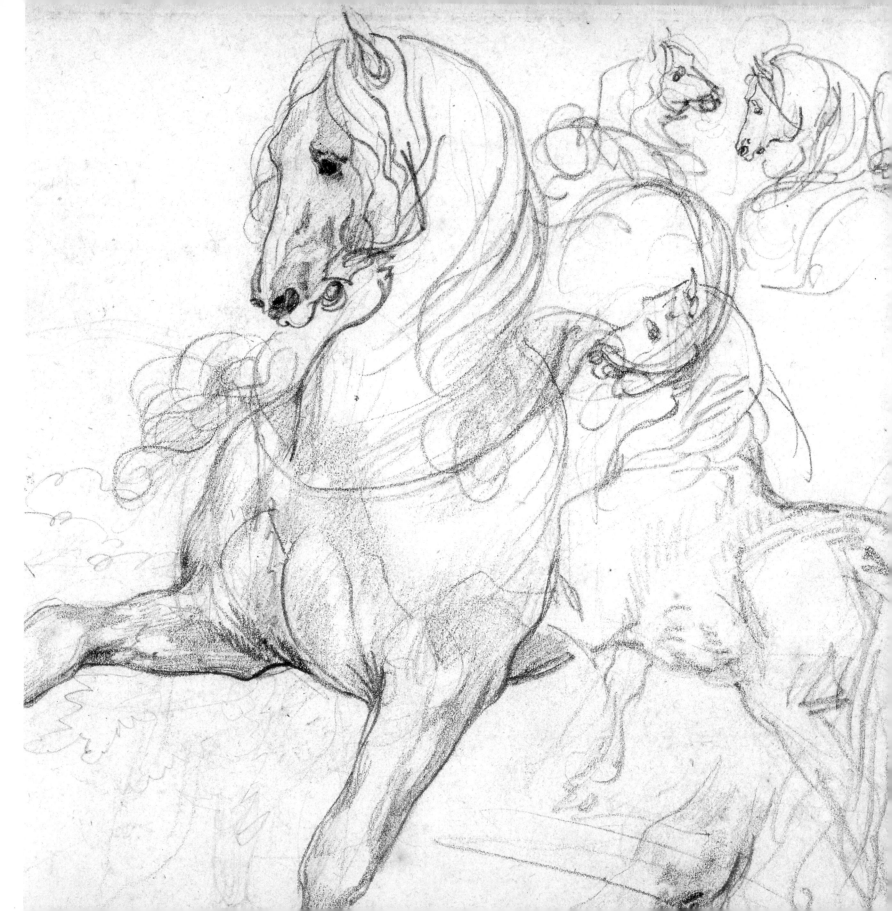

35

**Jean-Auguste-Dominique Ingres
(French, 1780–1867)**

*Portrait of Charles Hayard and His
Daughter Marguerite*

1815
Graphite
30.8 x 22.9 cm (12⅛ x 9 in.)
British Museum, 1968,0210.19

WITH A CAPABILITY THAT makes such
draftsmanship look easy, Ingres has conjured
a startling representation from a blank sheet.
He used a wide variety of types of line, dif-
ferent pressures, and *stumping* (down the
side of the nose and above the left eye) for
Hayard's form, but the most immediately
captivating aspect is the wispy treatment of
the hair. Just enough information is provid-
ed to enable the viewer to fill in missing de-
tails, and the patches of hatched lines, when
viewed at a distance, create an impression of
great intricacy and detail. Less attention is
given to the figures' clothes.

Although Ingres went to Rome to
study and gain a reputation as a painter of
history subjects, he earned his living by mak-
ing painted and drawn portraits of visitors.
Hayard was a fellow Frenchman who had
also moved to Rome with his family and ran
a shop selling artists' supplies. Ingres has
signed and *dated* the sheet at lower right
and dedicated it to Hayard's wife ("Ingres
à / Madame Hayard / Rome 1815"); a drawn
pendant (paired) portrait of her with another
daughter is in the Fogg Art Museum, Cam-
bridge, Massachusetts.

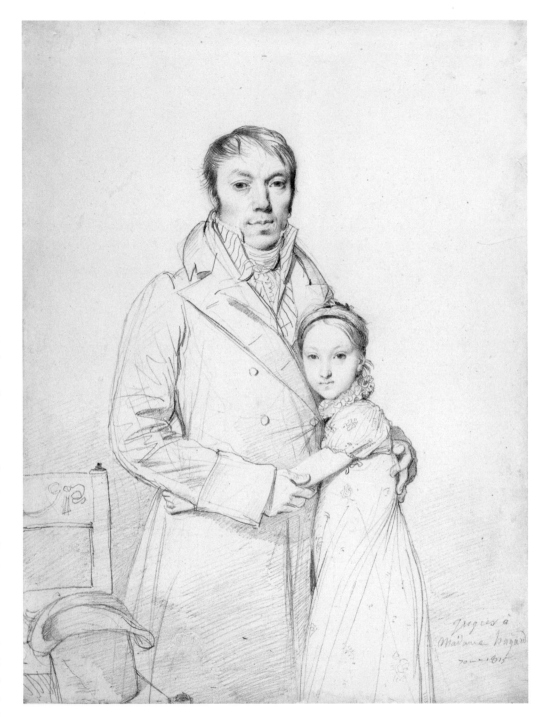

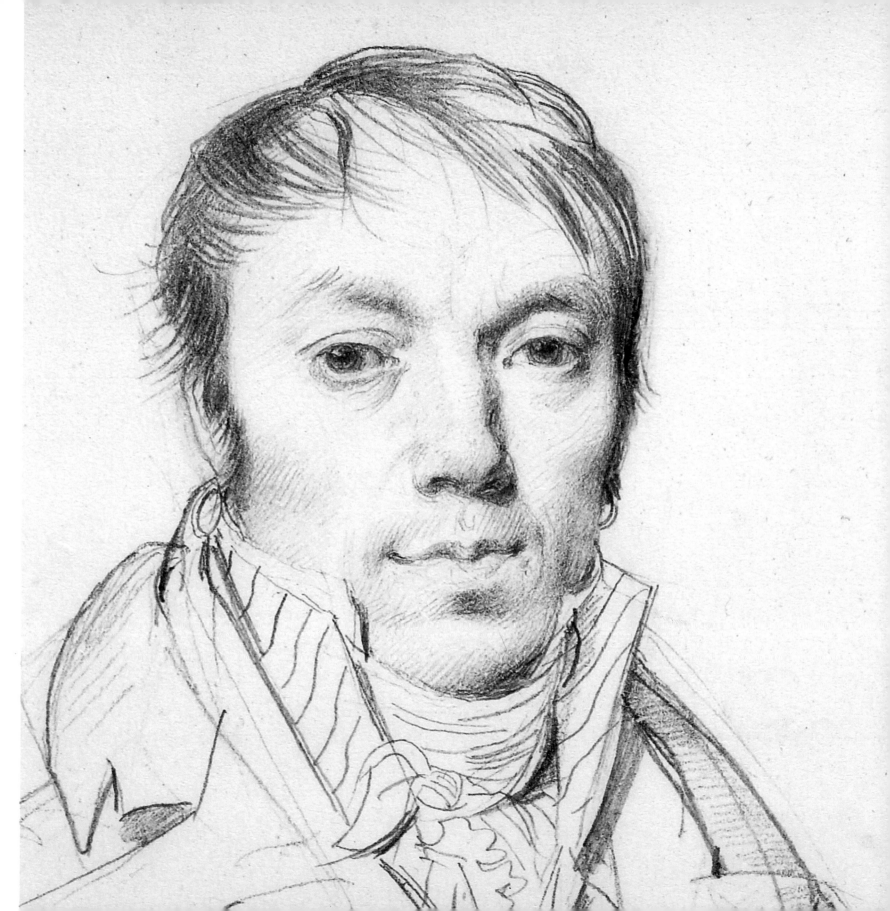

36

**Francisco José de Goya y Lucientes
(Spanish, 1746–1828)**

Inferno

Ca. 1818–19
Lithographic ink wash
15.4 x 23.2 cm (6⅛ x 9⅛ in.)
British Museum, 1876,0510.374

MOST FAMOUS FOR HIS PORTRAITS and his brutal representations of the horrors of war, Goya created this drawing as a preliminary study for a lithographic print. It is drawn in a slightly greasy tusche, or lithographic ink wash, which Goya often used in his later years when his activity as a lithographic printmaker increased. The result is a symphony of grays, with dark pools of grainy wash alongside areas where the artist employed *starved a brush* to create scratchy, wispy effects, for example at right. The tumultuous and horrific scene is made entirely with the brush, the tip of which is used to delineate the ghoulish demons. Goya drew his own ink line border on the sheet in the same wash he used for making the drawing, giving it the sense of a finished work.

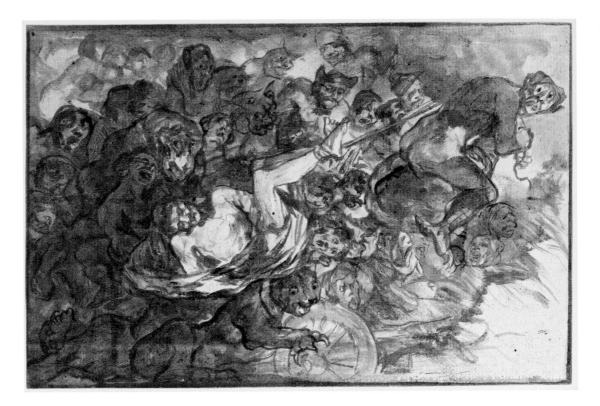

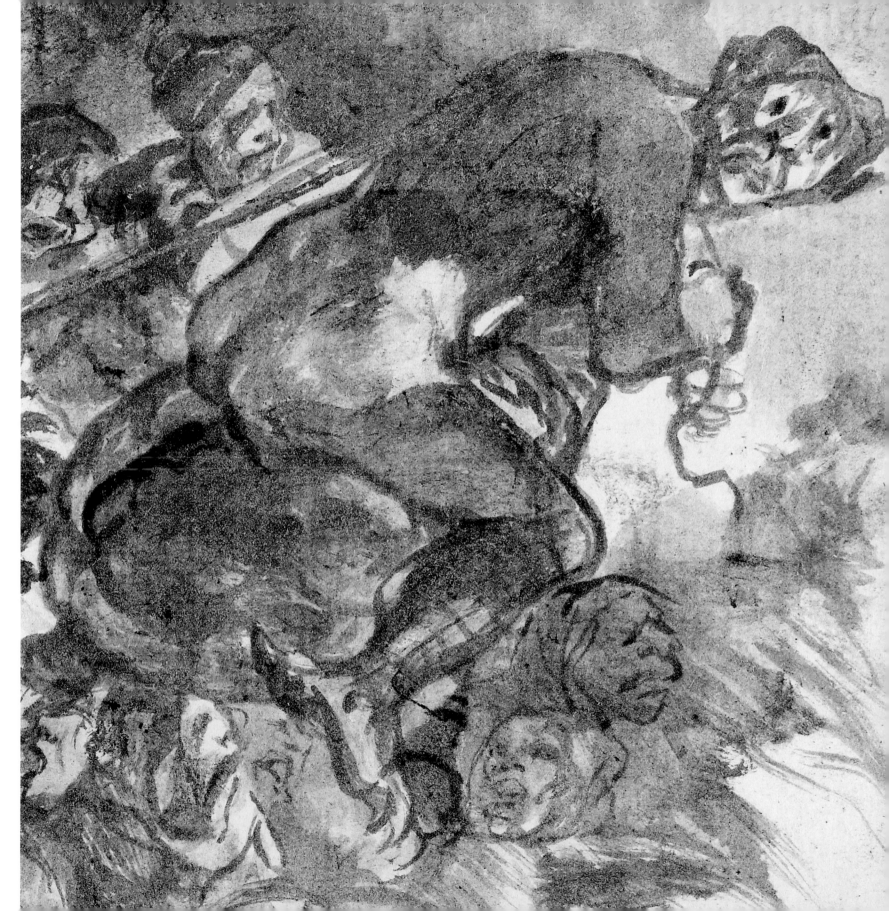

37

Thomas Shotter Boys (British, 1803–1874)

A View of the Church of Our Lady of Hanswijk, Mechelen (Malines), Belgium

1831
Watercolor over graphite
26 x 36.8 cm (10¼ x 14¼ in.)
J. Paul Getty Museum, 2008.46

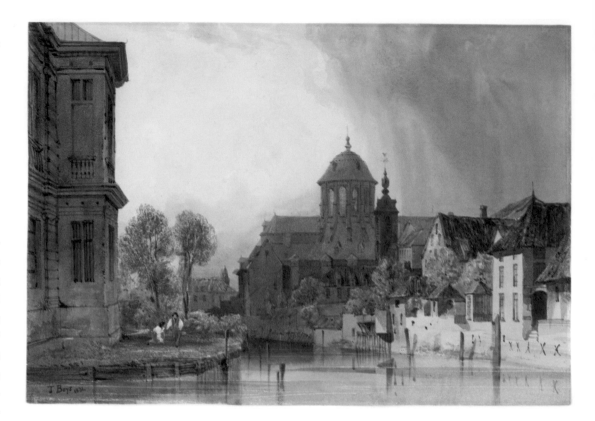

IMMENSE CONTROL OF THE *watercolor* medium is evident here as Boys depicts a sunbathed Mechelen canal with an impending storm in the background. Flecks, dashes, and strokes of watercolor of different intensities capture the details of the houses; the roof of the house at farthest right, for example, is conveyed by a mottled brown *wash*. With a pointed implement, Boys *scratched out* horizontal lines in the glasslike surface of the water, helping create the sense of reflection and giving grades of distance. Known for his accuracy in depicting townscapes, Boys published a book of views of Continental cities in 1839. However, this watercolor was made as an *independent work* for sale and is *signed* and *dated* at the lower left.

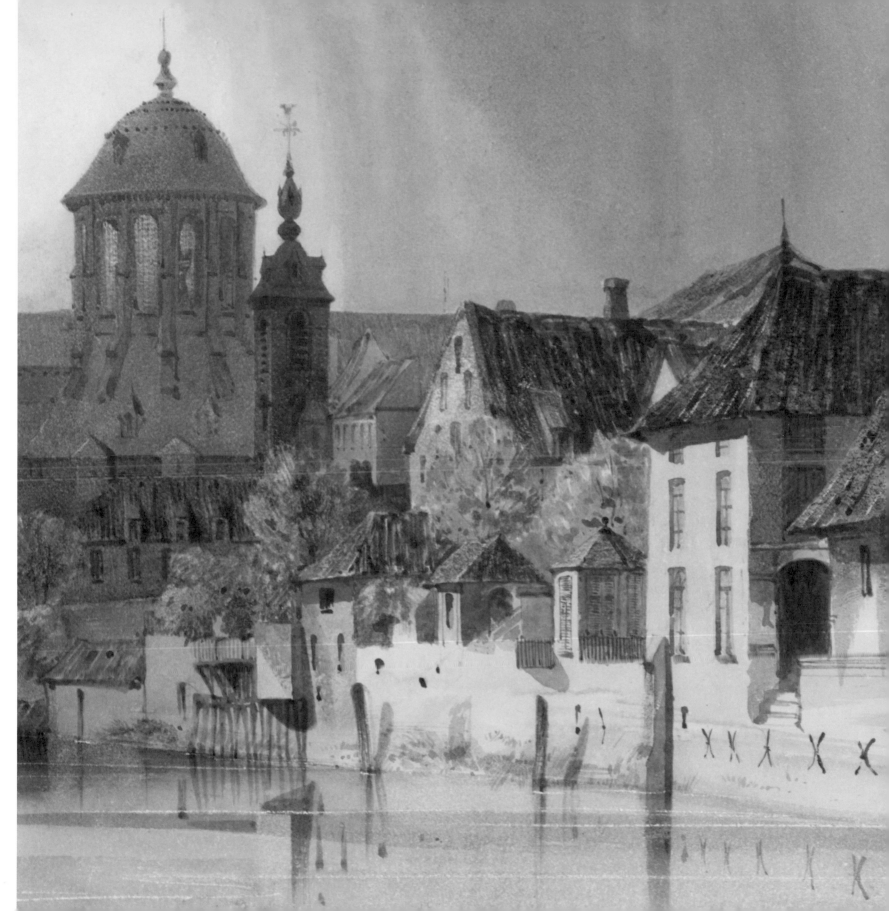

38

Eugène Delacroix (French, 1798–1863)

Study of a Seated Arab

1832
Black, red, and white chalk, brush with
red wash, on buff paper
30.8 x 27.4 cm (12⅛ x 10¾ in.)
British Museum, 1968,0210.24

ON A VISIT TO SPAIN, Morocco, and Algeria
in 1832 Delacroix made a mass of sketches
recording local subjects. These drawings be-
came a valued repertoire of material for the
rest of his career. In this study of an Arab
seated on a chair the artist depicted the
striped robe of the sitter with *black chalk*
lines of varying thicknesses, using greater or
lesser pressure. The variety provides a sense
of the volume and fall of the robe with decep-
tive simplicity. The profile view of the face is
the most highly finished part of the drawing,
with black, white, and red chalks used to-
gether. A larger-scale *subsidiary study* of the
profile provides greater detail, and in the top
right corner Delacroix tested the chalk with
a squiggle.

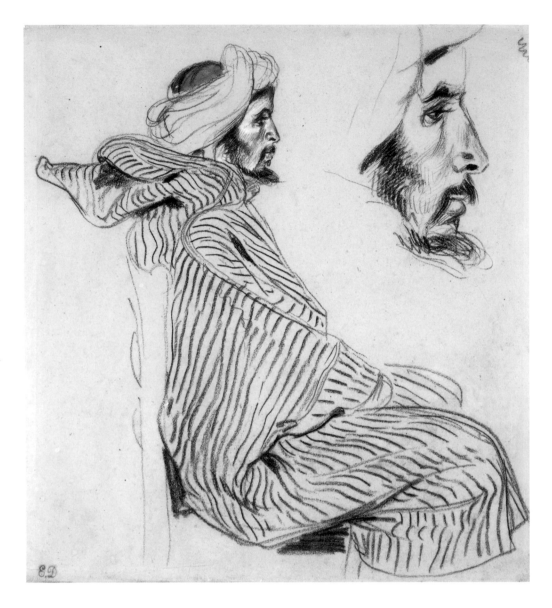

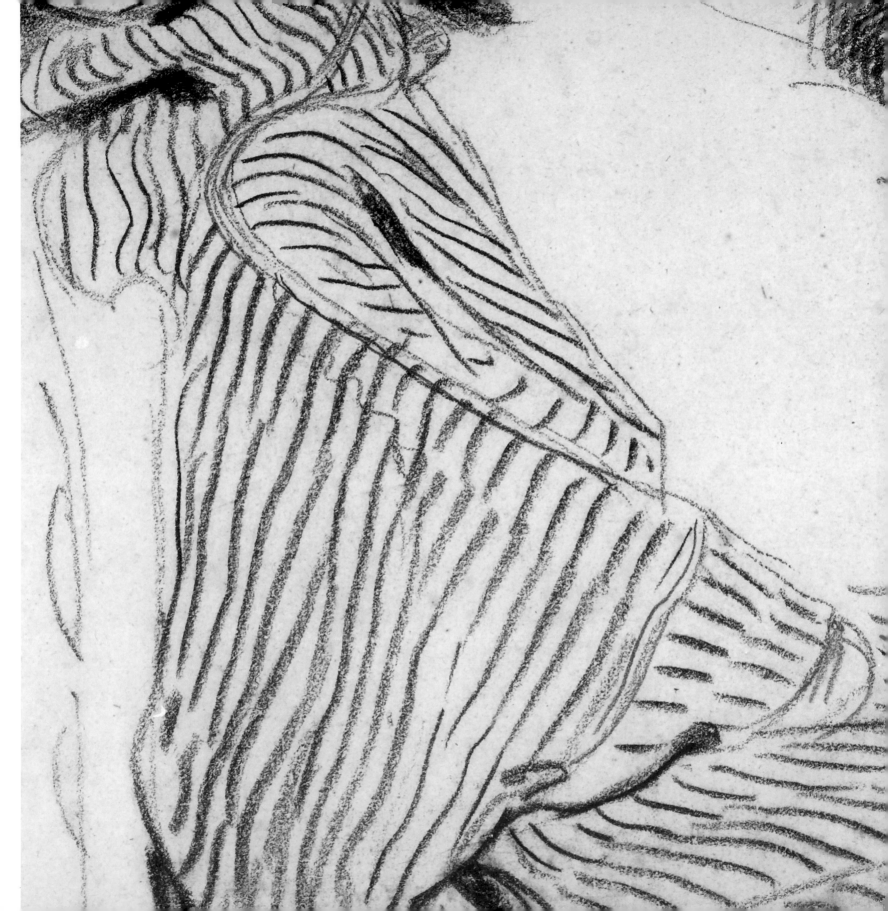

39

**Joseph Mallord William Turner
(British, 1775–1851)**

Long Ship's Lighthouse, Land's End

Ca. 1834–35
Watercolor and gouache
28.6 x 44.7 cm (11¼ x 17⁵⁄₁₆ in.)
J. Paul Getty Museum, 88.GC.55

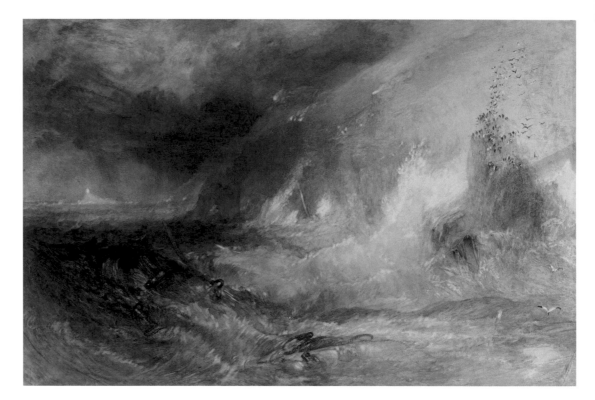

ONE OF THE MOST INNOVATIVE masters of the *watercolor* technique, Turner used swathes of *wash* in combination with *blotting* (with a rag wrapped around his finger) and *scratching out* to capture these tempestuous effects. Turner employed a fine brush with intense black watercolor to create the cloud of gulls at right, while all the patches of white for gulls caught in sunlight were made by *scratching out* the surface of the watercolor to reveal the white paper; Turner apparently grew his thumbnail particularly long so he could use it for this purpose. A few gulls in the distance are drawn only in gray watercolor. Just above the vivid curl of a blue wave crashing on the rocks, Turner's thumbprint is visible. He deliberately used his thumb several times to scuff the watercolor and add texture to that area. Employing a combination of dramatic effects and picked-out details, Turner was adept at realistically capturing the power of nature.

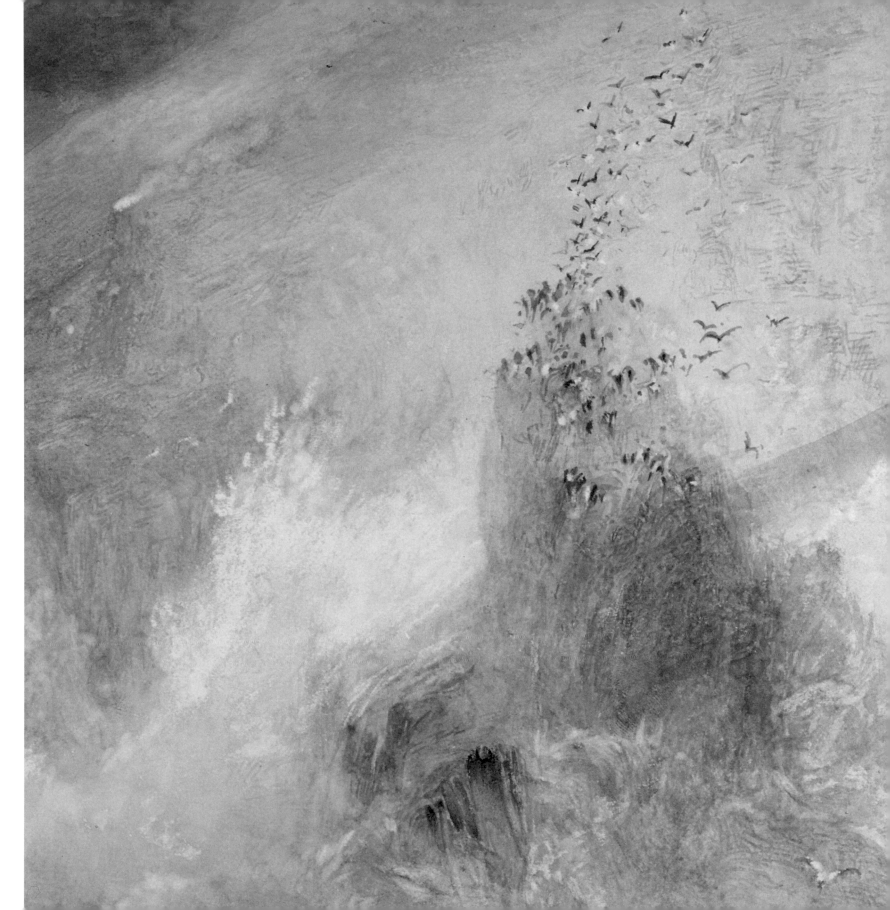

40

Edward Lear (British, 1812–1888)

Petra, April 14, 1858

1858
Pen and brown ink over pencil with watercolor and gouache on blue paper
36.2 x 54 cm (14¼ x 21¼ in.)
J. Paul Getty Museum, 2008.45

EDWARD LEAR TRAVELED widely and used pen sketches to record what he saw. At the end of his trips, back in the studio, he applied *watercolor* washes to the compositions based on *color notes* (see "bright grass," "dark," "all shade," and other *inscriptions* here). He also made large oil paintings of these scenes for sale. We know from his journal that Lear had only a short time in the famous city of Petra (in present-day Jordan); he had spent six days getting there by camel but was besieged by tribesmen demanding money and could only make a handful of sketches. This one took Lear thirty minutes, and he inscribed it "7.30.am," his choice of vivid *blue paper* no doubt reflecting the cool early morning light.

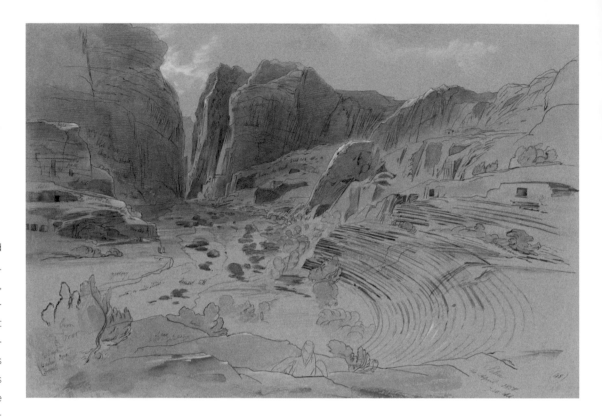

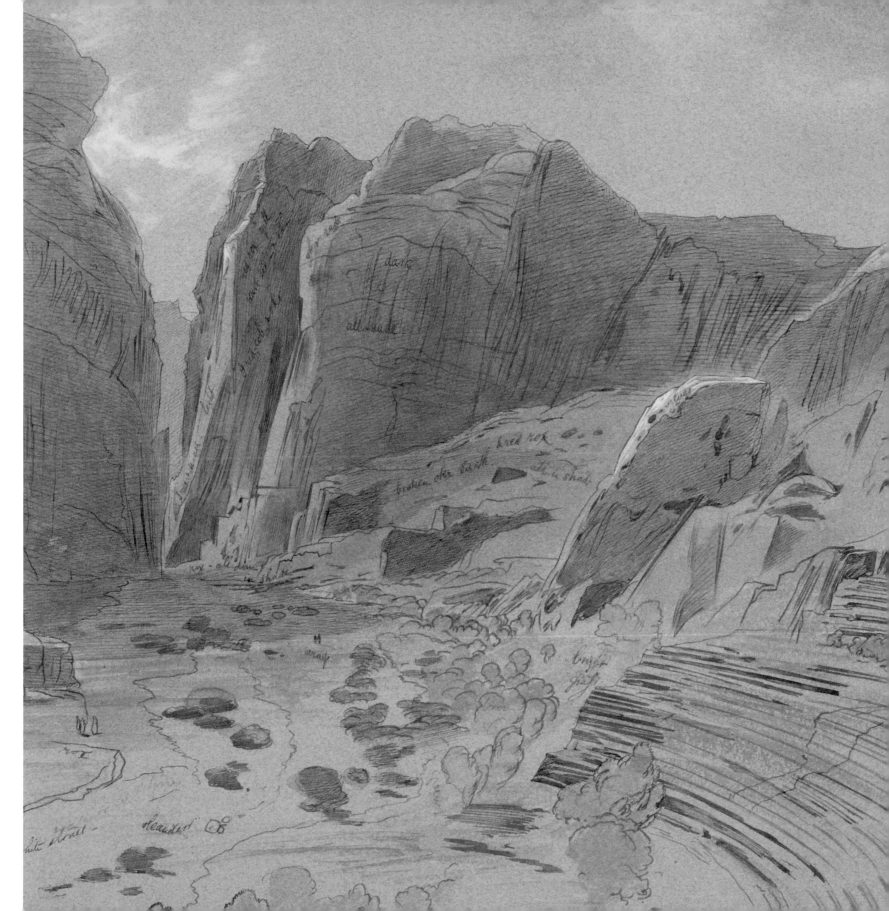

41

Edgar Degas (French, 1834–1917)

Two Dancers at the Barre

Ca. 1873
Oil paint thinned with turpentine, on
green prepared paper
47.2 x 62.5 cm (18⅝ x 24⅝ in.)
British Museum, 1968,0210.25

DEPICTIONS OF THE BALLET have be-
come almost synonymous with the name of
Edgar Degas, and he drew and painted this
theme—both finished performances and in-
tense training sessions—almost to the point
of obsession. In this work the line between
drawing and painting has been blurred by
Degas's use of *essence* (oil paint thinned with
turpentine) on a rich green *prepared paper*.
Although it dries to a hard, granular surface,
essence can be freely applied like *water-
color* with a brush, and the speed with which
Degas worked here can be seen in the rapid
strokes of black, white, and gray paint.

　　The two separate figures in this
study, each absorbed in her own practice
and in different pictorial spaces, were com-
bined into a single space for a painting now
in the Metropolitan Museum of Art, New
York. Degas later included a color reproduc-
tion of this drawing in a book of twenty pub-
lished in 1897.

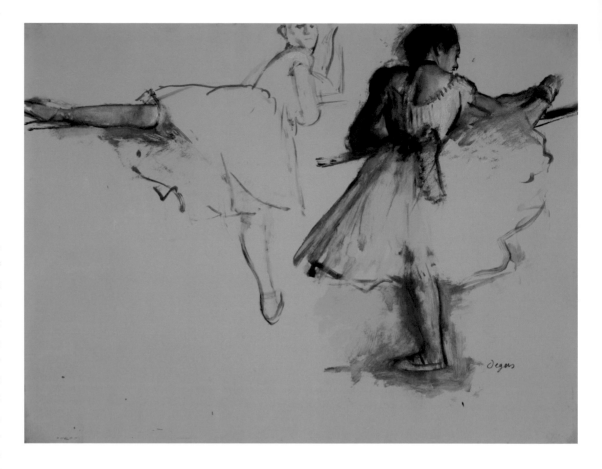

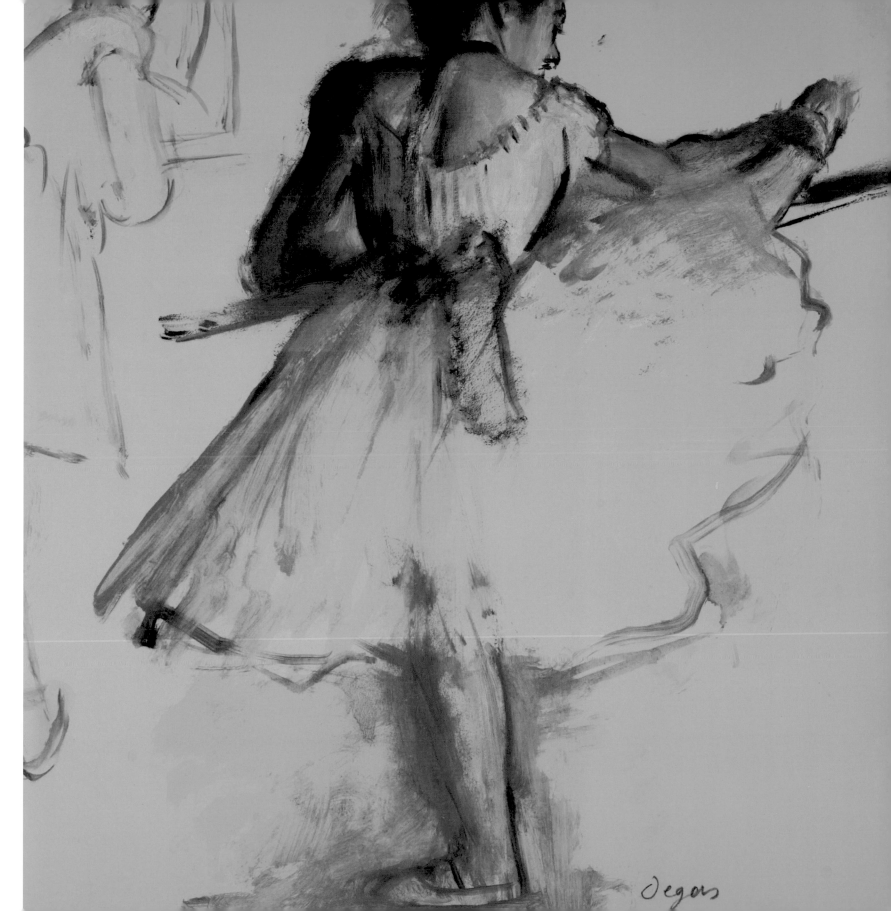

42

Georges Seurat (French, 1859–1891)

Madame Seurat, the Artist's Mother

Ca. 1882–83
Conté crayon on Michallet paper
30.5 x 23.3 cm (12 x 9³⁄₁₆ in.)
J. Paul Getty Museum, 2002.51

WITH HARDLY A SINGLE line, Seurat has here modeled the ghostlike form of his mother's face using the graded application of *conté crayon*, leaving modulated sections of white paper to represent her features. He chose his preferred Michallet brand of paper, which was relatively thick and had a grainy texture that provided "tooth" for the crayon. This enabled the exaggerated, shadowy effects he sought, a technique he called *irradiation*. Aged just twenty-three or so when he made this powerful image, Seurat dined with his mother almost every evening; he presented this drawing to her as a gift. He died only a few years later, before she did.

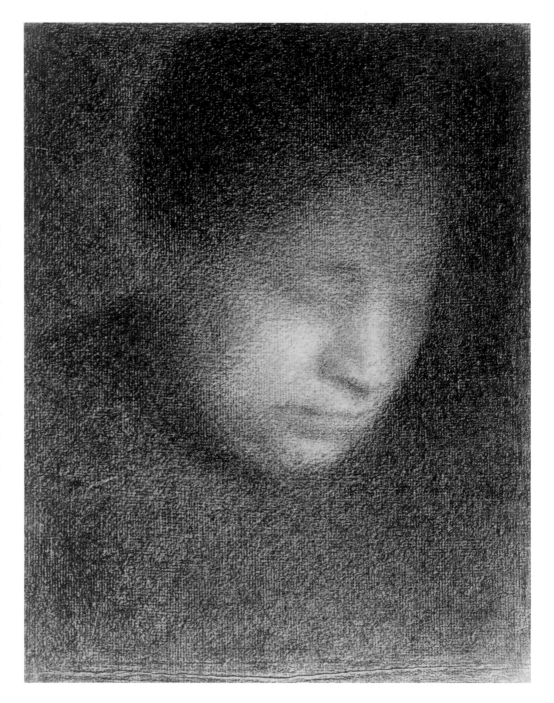

43

Vincent van Gogh (Dutch, 1853–1890)

Portrait of Joseph Roulin

1888
Reed and quill pens and brown ink and
black chalk
32 x 24.4 cm (12⅝ x 9⅝ in.)
J. Paul Getty Museum, 85.GA.299

IN THIS INTENSE PORTRAIT of his friend, the
postal worker Joseph-Etienne Roulin, Van
Gogh used a wide variety of lines drawn with
both *reed* and *quill* pens. The background,
rendered with a patchwork of the fluid zig-
zagging lines typical of a quill pen, contrasts
with the series of shorter, thicker, reed pen
strokes used for the rounding of the hat.
Much of the face was also drawn with a reed
pen: insistent stumpy strokes of dark ink rep-
resent the eyebrows, and *hatching* and *cross-
hatching* make shadows on the cheeks. Reed
pen lines of varying lengths and thicknesses
characterize the spiky hair and bushy beard.
Van Gogh created this drawing as a record
of his own oil painting of Roulin and sent it
to a painter friend, John Russell, on August
3, 1888.

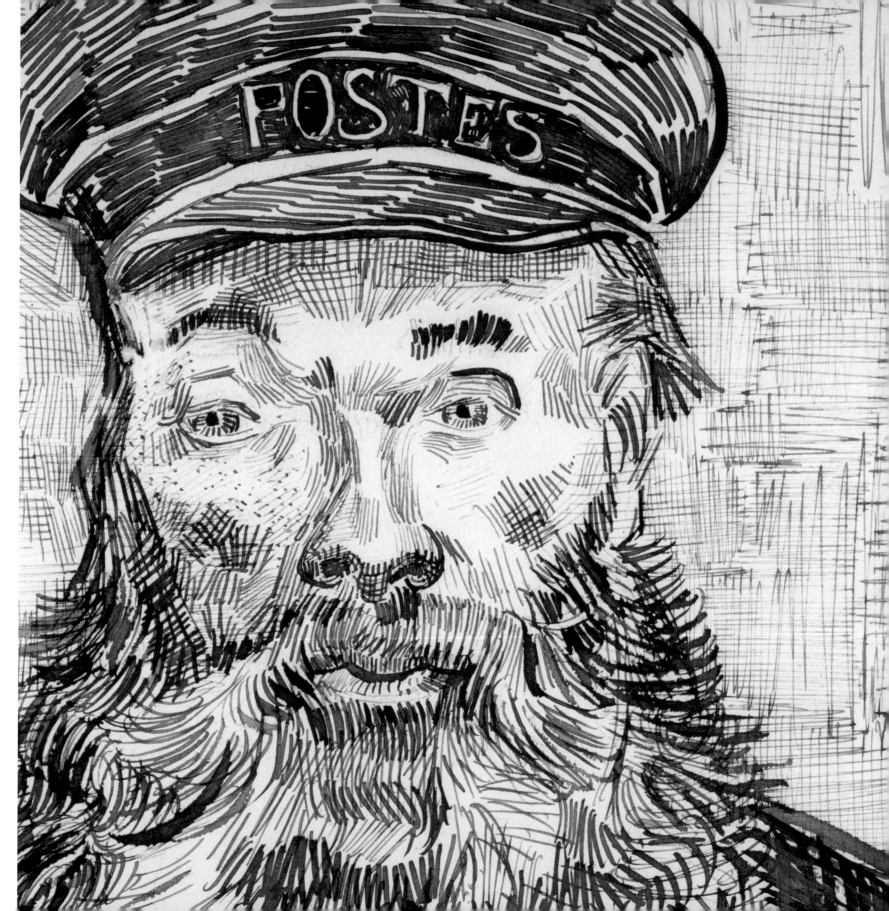

44

Albert Dubois-Pillet (French, 1846–1890)

The Banks of the Marne at Dawn

Ca. 1888
Watercolor over traces of black chalk
15.8 x 22.2 cm (6¼ x 8¾ in.)
J. Paul Getty Museum, 2008.25

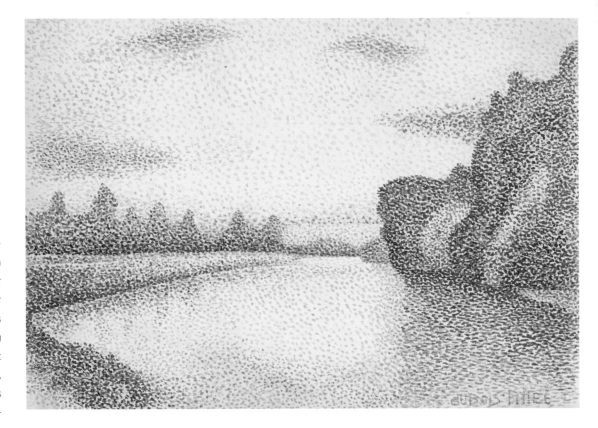

DUBOIS-PILLET WAS ONE OF the first artists to adopt a pointillist technique, through which scenes are rendered in small dots or dashes of pigment to give intensity of color and the effect of vibrant light. Here he has enjoyed capturing the hazy early morning light, the shadowy line of trees on the left (which includes vivid spots of red-orange), and the reflections on the water. While this view is also treated in a painting by Dubois-Pillet in the Musée d'Orsay, Paris, the composition in the drawing is more abstracted. The sheet was likely made as an *independent work* of art for a collector, rather than as a preparatory study for the painting. The artist has *signed* the drawing at lower right (also in dashes of watercolor), a further indication that it was intended as a work of art in its own right.

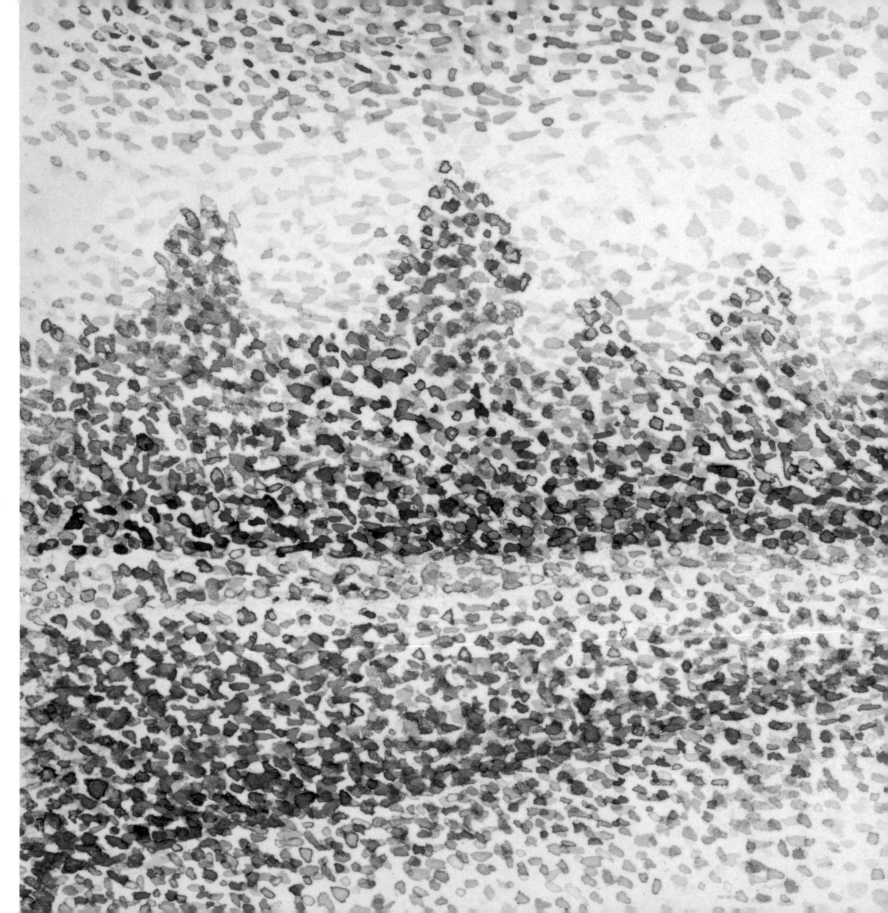

45

Odilon Redon (French, 1840–1916)

Head of Christ

1895
Charcoal, black pastel, and black
crayon; stumping, erasing, and incising
on buff paper
52.2 x 37.9 cm (20½ x 14⅞ in.)
British Museum, 1921,0411.1

ONE OF REDON'S *NOIRS*, large, intense
drawings created in dark media for transfer
into lithographic prints or for sale to collec-
tors, this sheet reflects the haunting, dream-
like imagery often found in his work. By his
own confession Redon was "terrified of a
sheet of white paper . . . it makes me ster-
ile," and here he toned the tan paper more
golden with a resinous balsam *fixative* before
working in a complex mix of dark media. He
created the drawing over a base of swirling
lines of gray-black soft *charcoal* and used
velvety black *pastel* for finishing touches,
including parts of the crown of thorns. Re-
don also employed *subtractive techniques*,
such as *scratching out* and erasing (some of
the gaps in the tousle of thorns and hair are
erased), and he zigzagged a *stump* across
some of the lines to create additional strokes
in a parallel direction.

 Radiating lines at the top and right
of the sheet give a sense of energy and ex-
plosion, contrasting with the lolling head
and its vacant expression. Redon signed the
sheet at lower right and sold it directly to a
British collector of his work, Edward Tebb.

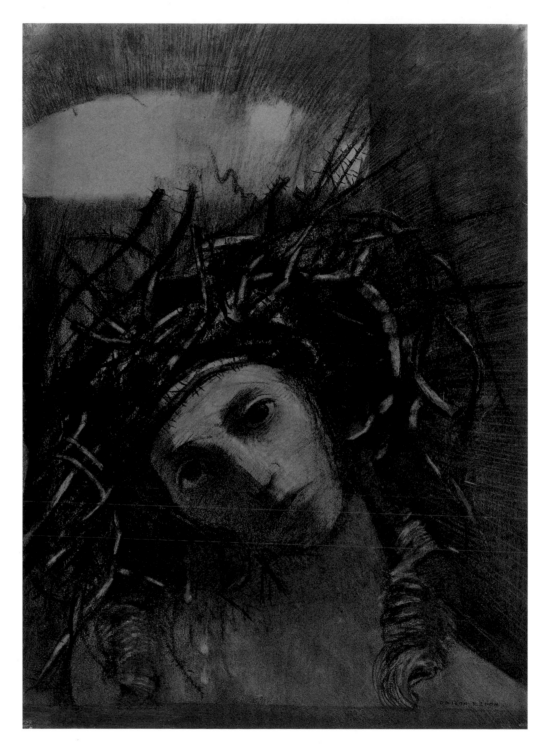

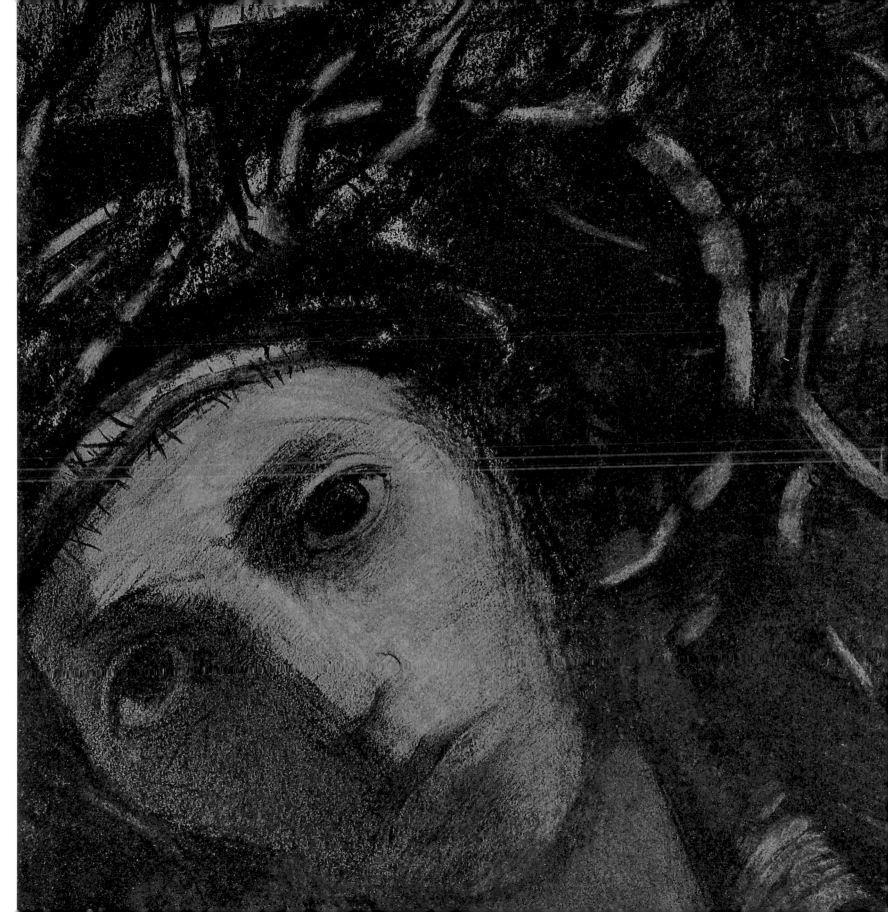

Figure 1. "Someone told me we're just marks on a piece of paper," soft pencil and wax crayon, 14 x 10.2 cm (5½ x 4 in.), ca. 1985–86. Cartoon by Mel Calman, © S. & C. Calman.

LIST OF COMMONLY USED MEDIA

SUPPORTS

Vellum

Laid paper

Wove paper

DRY MEDIA

Metalpoint

Black chalk

Red chalk

White chalk

Colored chalks

Charcoal

Pastel

Graphite

WET MEDIA

Quill pen, or

Reed pen, with

 Carbon ink

 Iron gall ink

Brush, with

 Wash

 Watercolor

 Gouache

BRIEF GUIDE TO TERMS USED IN THE STUDY OF MASTER DRAWINGS

Note: Many of these terms are also used in the study of paintings, decorative arts, or prints; the definitions provided here concern drawings in particular.

After [Guercino] | A later imitation/duplication of a specific work by [Guercino].

Attributed to [Guercino] | A work very likely by [Guercino], but where some doubt about the authorship of the work exists.

Attribution | The identification of the artist who made a particular work of art. Since most drawings are not signed, their attribution is generally determined through stylistic comparison with other sheets or by a relationship to a painting or other work that is signed or can be attributed by reference to archival documents.

Bistre (or **bister**) | A wash created by boiling chimney soot in water, and filtering it to remove residue. Depending on the type of wood burned (usually hardwoods, such as beech or oak), this creates a beautiful luminous color that can range from a light golden brown to a deep yellow-brown. Although known and used from the 1400s, bistre was particularly popular in Venetian drawing of the 1700s. See no. 32.

Black chalk | Naturally occurring black chalk has been widely used as a drawing medium since the 1500s, when it was principally mined in France. It soon replaced *charcoal* and was used in Florence for *cartoons* and preparatory studies (see, for example, nos. 6 and 11) and—in combination with *blue paper*—in Venice, where tonal effects of light and shade were particularly sought after. Black chalk produces a gray or black line, sometimes spotty or grainy because of impurities, and can be erased with an eraser or (as in earlier times) by rubbing with a piece of stale bread or bread crumbs. Natural black chalk was sometimes ground and mixed with a binder or gum to produce a more consistent synthetic *crayon*. Occasionally

lamp black was added, which darkened the resulting line.

Blotting | Removing wet watercolor with a tool such as a rag (sometimes wrapped around a finger for precision). This lightens the tone of an area and can also be used to scuffle or smudge the wash.

Blue paper | Beginning in the late 1400s, blue paper was made from cotton or linen rags dyed blue with indigo or woad. In the later 1500s this color was sometimes enhanced by adding a dye extracted from logwood to the pulp. Other colorants that came into use included turnsole, solubilized indigo, Prussian blue, and smalt. Much blue paper has faded with exposure to light, the blue pigment often being fugitive. The result is a green or green-blue tinged paper. Occasionally a white paper was brushed with a blue preparation (see *prepared paper*) to create the effect of blue paper.

Bodycolor | See *gouache*.

Carbon ink | First used in ancient Egypt, and in China about 2500 BC, carbon ink is made by mixing powdered soot from burned oil, fat, resin, or resinous wood (*lamp black*) with water and plant gum or animal glue. Often described simply as "black ink," it produces a black line that does not discolor with time.

Cartoon | A preparatory drawing made in the same size as the destination work so that the composition could be transferred directly by *pouncing* or *incising*. The term derives from the Italian *cartone* (large sheet of paper); the size of cartoons meant that they were often made from several sheets of paper joined together. See no. 11. The alternative meaning of "cartoon" as a humorous drawing derives from the parodies of fresco designs submitted for the Houses of Parliament in London that were published in *Punch* magazine in the 1800s.

Charcoal | A drawing stick traditionally made by heating wood in an airtight container in the embers of a fire, the lack of oxygen causing the wood to turn largely to carbon but not to ashes. The best sources for charcoal are even, knot-free pieces of vine, willow, beech, or lime. Charcoal is crumbly and dry, leaving an uneven line, which is easily erased with bread crumbs or a feather. Consequently, it was generally used with a *fixative*. It can be seen to glisten in the light. Charcoal was sometimes soaked in linseed or olive oil to give it a more consistent texture and a better adherence to the paper. Although it has been known since ancient times, charcoal was employed intermittently in Italy and Germany in the 1500s, sometimes for *underdrawing*, and enjoyed a particular vogue in French academic and landscape studies of the 1800s.

Chiaroscuro | From the Italian *chiaro* (light) and *scuro* (dark), a term generally used to describe a composition including strong contrasts of light and shadow.

Circle of [Guercino] | A work produced by an artist associated with [Guercino] or acquainted with his output but not in his studio.

Collector's mark | A mark or symbol, often incorporating or comprising a letter or some initials, applied to a work of art to denote ownership. Most were stamped in black, gray, or red ink, but some were dry stamps (a pressure stamp leaving an impression but using no ink). Sometimes marks were applied after the death of a collector to signify *provenance*. Collector's marks have been used for centuries by private individuals and institutions such as museums; they are generally small and reasonably unobtrusive. During the 1900s, their use came to be considered unacceptable, and they were seen to be visually intrusive and unnecessary. They are now rarely employed, although still occasionally applied to *mounts*. Collector's marks are often referred to by L. or Lugt numbers, a reference to the important compendia by Frits Lugt (see Further Reading below). See, for example, nos. 24 and 30.

Color notes | Inscriptions on a drawing or watercolor noting the various colors of the scene or object depicted, generally used as a reminder or as an indication that the artist would add those colors to the work at a later date. See, for example, nos. 1 and 40.

Compositional study | A drawing made to plan the disposition of the figures (and/ or buildings, landscape, etc.) in prepara-

tion for a painting, print, sculpture, or work of decorative art.

Conté crayon | A fabricated chalk crayon or graphite pencil; clay was added to the base material to produce a substance of varying hardness. These crayons were invented by Nicolas-Jacques Conté, who patented the process in 1795. See also *crayon.*

Copy | A reproduction of another work, either precise or freely adapting the original, made at any date.

Counterproof (or **offset**) | An image produced by placing a blank sheet of dampened paper on an original drawing. By the application of pressure, particles of chalk from the original sheet are transferred to the dampened one, resulting in a second, reversed, image which is generally less well defined. See no. 21. Artists through the centuries have regularly used counterproofs to evaluate the effect of a pose facing in the opposite direction, and printmakers have found the process useful since it anticipates the reversal that occurs in the printing process. Since making a counterproof involves dampening one or both sheets of paper, it is most effective when used with dry media such as red or black chalks. Some artists (for example, Guercino) would occasionally work up the counterproof to produce a new drawing. Of course, counterproofs could also be produced from drawings long after an artist's death, and

they have sometimes been produced by dealers for sale or deceitfully sold as original drawings.

Crayon | An ambiguous term generally used to refer to synthetic sticks of drawing material bound with a fatty or waxy binder, as opposed to natural *black chalk* or *red chalk.* See also *Conté crayon.*

Cross-hatching | Parallel lines of hatching that have been crossed by another set of hatching, at a steep or shallow angle, to produce a structuring effect suggesting greater three-dimensionality or shadow. See, for example, no. 1.

Dated | Occasionally a drawing will be inscribed by the artist with the year in which it was made, but in general drawings can only be dated by reference to another work (painting, etc.) that can be securely dated through archival documents. Drawings can themselves in some instances be dated by archival methods. Sometimes, when an artist's style changes in an ascertainable pattern during the course of his/her career, drawings can be dated by reference to other sheets.

Dry brush | See *starved brush.*

Essence (French pronunciation) | Oil paint from which the oil has been removed by spreading it on blotting paper; the resulting pigment was then thinned to a usable consistency by adding turpentine. The technique was used by French

painters of the late 1800s, including Henri de Toulouse-Lautrec and Edgar Degas, who called it *peinture a l'essence* (painting in essence). See no. 41.

Figure study | A drawing made to capture the form, posture, and/or appearance of a figure, either clothed or not. While such studies are often made from life, from a studio model, or observation, this need not necessarily be the case. Figure studies were frequently made as the step following the *compositional study* in the preparatory process for a painting. See nos. 7, 17.

Fixative | Material applied to a work in dry media such as chalk, charcoal, or pastel to "fix" it (i.e., aid its adherence to the support, e.g., paper). While most master drawings were not fixed, fixatives have been known since the 1400s. The simplest was egg white, brushed over the sheet. Otherwise works were immersed in a bath made of water mixed with *gum arabic* and dried, or, as commonly happened, this mixture could be blown onto the sheet with a pipette. Gum could also be applied to the paper prior to drawing and then the sheet steamed afterward to bond the media and the support.

Follower of [Guercino] | A work by an artist acquainted with [Guercino's] style, but probably active at a later date.

Foreshortening | A technique that creates the illusion of spatial depth for figures

or forms within a composition by using linear perspective.

Format | The particular shape or scale of a drawing or painting surface.

Framing lines | Lines drawn at the border of a composition or the edge of a piece of paper to contain a design. They might be drawn by the artist or at a later date by a collector or a mount maker.

Gouache (also called **bodycolor**) | A water-soluble paint made by mixing pigment with a binder of *gum arabic* and honey, which is then made opaque by the addition of lead white, chalk, or, after 1834, zinc oxide. White gouache could be used for *white heightening*. Although known in ancient Egypt, it was widely used in Western art beginning with medieval manuscript illumination and, later, often employed in combination with watercolor. Depending on the mixture, it can be more or less opaque and can have a velvetlike texture. Its opacity brings drawing closer to the art of painting.

Graphite | The principal component of a pencil, natural graphite has been mined in England and elsewhere since the 1560s. It only gained widespread use as an artist's material in the late 1700s and has been commercially manufactured since 1897. It creates a gray, granular line which is shiny in the light, particularly when seen under magnification. See nos. 34, 35.

Ground | A base layer added to a sheet of paper. See also *prepared paper* and *metalpoint*.

Gum arabic | Water-soluble gum from the acacia tree used as a binding agent. It is the basis for most watercolor paints, binding the media to the paper after the evaporation of the water. It can be seen to shine in raking light.

Hatching | A method of conveying three-dimensionality or shadow through a series of closely spaced parallel lines, sometimes varying in width.

High finish | Brought to a high level of completeness, probably using a complex mix of media (chalk, ink, wash, gouache, etc.), which often covers the majority of the surface of the paper. The term applies to a highly finished surface, although the composition may still be incomplete. The intention is often to make the drawing an *independent work. Modelli* are often also highly finished. See, for example, no. 29.

Highlights | Light points in a drawing created by *white chalk*, white *gouache*, *reserves* of white paper, or *scratching out*.

Imitator of [Guercino] | A work by a later artist who has sought to duplicate [Guercino's] style.

Incising / incised lines | Shallow grooves made in paper through the use of a pointed implement such as a stylus or the point of a

compass. Incising was sometimes used by artists for *underdrawing* or on *cartoons*, but it more frequently played a part in making copies (blank paper placed beneath the incised drawing picked up the incised lines) or making prints (the copper printing plate placed beneath the incised drawing picked up the incised lines). Incising is clearly visible in a raking light. See Figure 2.

Figure 2. View of a drawing in raking (angled) light to render *incised lines* visible. Detail of Rosso Fiorentino, *Study of a Male Figure*, ca. 1538–40, Los Angeles, J. Paul Getty Museum, 83.GB.261

Indented lines | See *incising / incised lines*.

Independent work | A drawing made as a work of art in its own right, perhaps for sale or presentation.

India ink (or **indian ink**) | So-called because it was mistakenly believed to have

come from the Indies; also called (more correctly) Chinese ink. It consists of *carbon ink* bound with animal glue and mixed with camphor and gives a rich, black line.

Inscription | Writing that appears on a drawing, sometimes written by the artist but often by someone else, which frequently concerns the *attribution*, subject of the work, or its *provenance*.

Iron-gall ink | Ink made by the chemical reaction between iron salts and gallotannic acid (from oak tree gallnut growths soaked in water or wine) mixed with *gum arabic*. Depending on the proportions of the ingredients, it produces a gray or pale gray line, which quickly oxidizes to become black. It is usually designated "brown ink," because that is how it appears today (the color turns brown with age). Iron-gall ink has been widely used for writing for centuries, but it was employed in master drawings from the 1500s onward. See, for example, nos. 22 and 23 and *iron-gall ink damage*.

Iron-gall ink damage | Damage to a support (normally paper) caused by *iron-gall* ink, generally the result of an imbalanced mixture. An excess of acid eats into the paper over time, sometimes blurring the ink lines and—in places where pools of ink were left—destroying small parts of the support entirely. See no. 27.

Japanese paper | A smooth, finely-finished paper in which the chain or laid lines are hardly visible. It can vary in color and

in thickness but is normally extremely thin; occasionally several thin sheets will be layered to make a thicker sheet. It is sometimes called "Asian paper" or "Chinese paper"; its origins are not always clear. Although by the 1800s there were numerous sources, we do know that paper was imported from Japan into Amsterdam in the 1600s. Rembrandt used Japanese paper to bestow a certain exoticism on his drawings (see no. 24) and also made prints on it.

Laid paper | The principal type of paper used for master drawings, and indeed every other purpose, until at least 1750 (when *wove paper* started to become available). To create laid paper, cotton or linen rags were immersed in a vat

Figure 3. View of a mock-up paper mold, showing chain and laid lines in *laid paper* and a wired *watermark* device

with water and beaten to a pulp (the rags were often first whitened in lime water or through the addition of white chalk). Then a wooden frame (called a deckle) with a mesh of crossed wires (the mold) was immersed in the mixture and covered thinly and evenly with pulp. Once withdrawn, the deckle was overturned to release the raw paper onto a piece of felt and the paper was then covered with another piece of felt, pressed, and dried. Very absorbent, with the consistency of thick tissue paper, the sheets would need to be "sized" before use by soaking them in lime water or water mixed with animal gelatin (later, from about 1650, alum was used for sizing). Laid paper contains the visible lines of the wire mesh when held up to the light: vertical chain lines (between 2 and 5 cm apart) and tightly packed horizontal connecting laid lines. See Figures 3 and 5, *blue paper*, and *watermark*.

Lamp black | A type of carbon black obtained from the soot of burned oil, fat, resin, or resinous wood.

Leadpoint | See *metalpoint*.

Manner of [Guercino] | A work made in [Guercino's] style but of a later date.

Medium (plural: **media**) | The material(s) with which the work of art is drawn, e.g., red chalk.

Metalpoint | Drawing instrument consisting of a metal tip of lead, silver, gold,

or copper encased in a wooden holder. Before use, the paper would be coated with a preparation of white pigment, powdered bone, color pigment (if desired), and gum-water to give it the effect of fine sandpaper; this "tooth" enabled the instrument to leave a deposit of metal, which oxidized to give a soft gray or brown line. Used particularly in Tuscany and Umbria, metalpoint was time-consuming and difficult to erase; it lost favor among artists in the early 1500s when red and black chalks (more flexible, versatile media) became widely available. In manuscript illumination from the eleventh and twelfth centuries onward a point of lead alloy was used to rule lines as a base or frame for written words. See also *prepared paper*.

Mise-en-page (*placement on a page*) | Originally a printing term, this also refers to the distribution of motifs across a sheet of paper (i.e., how the artist chose, consciously or unconsciously, to place sketches on the sheet).

Modello (plural: **modelli**) | A comparatively highly finished drawing reflecting the final composition of the intended work. Modelli were used for several purposes: to assess the success of a composition; to delegate parts of the work to the studio; and to show to a patron to confirm or win a commission. Unlike a *cartoon*, which was the same size as the finished work, a modello was normally smaller than the intended work. See, for example, no. 25.

Modeling | In drawing, a term usually used to describe the sense of three-dimensionality or solidity brought to an object or a figure by graphic means. It is generally either conveyed through line (perhaps with hatching or cross-hatching) or tone (degrees of shading).

Monogram | An emblem or device, often incorporating initials or letters, used to identify a work as the product of a particular artist or workshop. or applied later as a *collector's mark*. See, for example, nos. 8, 30.

Mount | A surround, normally of board or card, used to protect a drawing for storage and display. A mount normally consists of a backboard to which the drawing is attached (in the past sometimes glued but now generally hinged), and a mat (or window), which is hinged to the backboard at the side or top, and which contains an opening to reveal the drawing. Mounts are now generally made of nonacidic material that will not damage the work over time. Standard mount sizes (as follows, height x

Figure 4. A museum cream-colored *mount*; the window is being held open (mount for Niklaus Manuel Deutsch, no. 8)

width) are employed by the British Museum and some other major museums: Half royal = 16 x 11 in. / 406 x 279 mm; Royal = 22 x 16 in. / 559 x 406 mm; Imperial = 27 x 20 in. / 686 x 508 mm; Atlas = 32 x 24 in. / 813 x 609 mm; Elephant = 38 x 28 in. / 965 x 711 mm; and Antiquarian = 44 x 32 in. / 1118 x 813 mm. See Figure 4.

Offset | See *counterproof*.

Parchment | See *vellum*.

Pastel (or **fabricated chalk**) | Dry drawing media comprising powdered pigments bound by a liquid binder (such as tree gum or fig juice) and then rolled and dried into usable sticks. While apparently first utilized by Leonardo da Vinci and early Italian artists, pastel sticks became commercially available in the 1600s and were widely employed in the 1700s, the heyday of pastel. They are most effective when used on a colored or prepared rough paper and produce a painterly result. See, for example, no. 29.

Patron | The person, group, or official body who commissioned a particular work from an artist or artists. The patron would generally dictate, or at least have a say in, the media, location, scale, and subject of the work.

Pencil | See *graphite*.

Pentimento (plural: **pentimenti**) | An Italian word that refers to visible changes

or corrections made by an artist in a work of art, deriving from the concept of re-penting (one's sins). Instead of erasing the previous lines, the artist just redraws the figure or object over them. See, for example, no. 12.

Pouncing | Transferring the design on a *pricked* drawing to the surface below by rubbing dust through the pricked holes, leaving a dotted line that could be worked up. Black chalk or charcoal dust (for a light-colored support) or powdered gesso or white chalk (for a dark support) was contained in a small, thin cloth bag with its end tied; the drawing was held against the support (e.g., fresco surface to be paint-ed), and the bag was tapped against the drawing along the pricked holes to cre-ate a same-size "dot-to-dot" replica of the original. See, for example, no. 11.

Preparatory, or preliminary, study | A drawing, either quickly or laboriously made, which works toward another, more finished, composition (e.g., a fresco, paint-ing, or other work of art). A preparatory study may have differences from the final work, and it may contain the whole com-position (*compositional study*) or just a section or a small part of it.

Prepared paper | Paper that is brushed with a liquid ground comprising a filler (e.g., plaster, ground eggshell, or bone white), a pigment for color (e.g., sinopia, or red earth, lamp black, yellow ocher), and a binder (e.g., gelatin, animal hide glue, or gum arabic). Prepared paper was often used in conjunction with *metalpoint* but also simply for colorful effects. See also *blue paper, metalpoint*.

Pricked for transfer | A case in which a drawing has a series of pricked holes along some or all of the compositional outlines to enable transfer by *pouncing*.

Provenance | The history of the owner-ship of a particular movable work of art. See also *collector's mark*.

Quill pen | A pen most often made from the feather of a duck, goose, crow, or swan; the shaft of the quill would be hardened by placing it in hot ashes and then sharpened as desired. The flexibility of the instrument, which produced a flowing calligraphic line made the quill the predominant artists' pen. It was largely replaced by pens with a metal nib, which became more widely available in the 1800s.

Recto | The "front" side of a sheet of pa-per and normally the most visually impor-tant. When drawings appear on both sides of a sheet of paper, the allocation of recto and *verso* can often be arbitrary or the re-sult of a decision by an early collector.

Red chalk (or **sanguine**) | Naturally oc-curring chalk consisting of hematite (iron oxide) suspended in clay. The limited tonal range of the output is counterbalanced by the attractive color, and some variations can be gained by *stumping* or by wetting the chalk. Deposits, ranging from purplish to brownish hues, were recorded across Europe, and the medium was a staple of draftsmanship in the early 1500s (espe-cially in Italy, and specifically Florence) and extremely widely used thereafter until replaced by synthetic crayons. Ground to a fine powder, red chalk could be used to make a red *wash*.

Reed pen | A pen made from a dried reed, cut short, and shaped to a blunt point. It typically produces short, thick lines and requires frequent refreshment of ink from the pot.

Reserve | An area of paper deliberately left blank so that the white/light color of the paper stands out as a *highlight*, base, or middle tone. Also sometimes called "negative space."

Scratching out | A technique in which the dried media on the paper are scratched out with a sharp implement (e.g., a stylus, a knife, or a fingernail) to reveal the white of the paper below. It could be used for making corrections but became a favor-ite technique of watercolor painters of the 1800s (e.g., J. M. W. Turner), who used it to create *highlights* or add white to a com-position. See, for example, nos. 37 and 39.

Sepia | Natural ink produced from the dark brown contents of the ink sac of a cuttlefish or squid. It was not widely used prior to the 1800s and can be difficult to tell apart from other inks.

Sfumato | From the Italian *sfumare* (to evaporate like smoke), the effect of smudging or softening transitions of tones or colors "without lines or borders, in the manner of smoke" (Leonardo da Vinci).

Signature (or **signed**) | The autograph signature of the artist applied to the work and thus claiming authorship. Since most drawings were casual preparatory works, they were not generally signed.

Silhouetted | Where the drawing has been trimmed to follow the outline of the figure or composition depicted.

Sizing (**paper sizing**) | Since raw laid paper was very absorbent, with the consistency of thick tissue paper, the sheets were "sized" before use by soaking them in lime water or water mixed with animal gelatin. Later, from about 1650, alum was used for sizing. See also *laid paper*.

Squaring | A grid drawn over the top of a composition to enable its transfer to another surface. Squaring was often used to help maintain the proportions of a design when it was transferred to a much larger format. See, for example, no. 25.

Stamped | A term often used to describe the application of a *collector's mark* to a drawing.

Starved brush | A technique whereby a brush is daubed almost free of wash or paint. It was sometimes judiciously used at the end of a stroke, so that the brush ran out of media at a certain point, thus yielding an intermittent and textured mark. See, for example, nos. 19, 36.

Studio of or **Workshop of** [Guercino] | A work produced by an unknown artist in the studio or workshop of [Guercino].

Stump (used for **stumping**) | A tightly rolled piece of paper, felt, or leather, tapered to a blunt point at both ends, gently rubbed or tapped on dry media (e.g., chalk) to blend the particles and give a line or area of work a softer appearance. It could also be used more aggressively to remove particles from the paper.

Style | In drawing, the distinctive "handwriting" or "artistic personality" revealed by the myriad decisions made consciously and unconsciously by an artist (preference of media, viewpoint, moment depicted, method of drawing human features, etc.) while creating a work. An artist's style may change throughout his/her career and can be more evident with works in some media than in others. Particular stylistic characteristics can sometimes be seen in the works of a particular group of artists, or school, or even among artists working in the same period, enabling one to discern approximately the date of an anonymous work. Style is one of the primary facets considered by connoisseurship to determine authorship.

Style of [Guercino] | A work made in [Guercino's] style but of a later date.

Stylus | A pointed implement, which *incises*/indents the paper, sometimes used for *underdrawing* or the transfer of a design.

Subsidiary study | A drawing—made subsequent to the primary sketch on the sheet—in which a detail or section is examined further.

Subtractive techniques | Techniques such as *stumping*, scraping, and erasing, which remove media from the surface of a drawing.

Support | The surface on which the work of art is made (e.g., canvas, vellum, or paper).

Tracing | A drawing made on—or via—translucent paper, often as part of a transfer process. While the term now carries negative connotations of a slavish approach and a lack of creativity, tracing was integral to the working process in past centuries. A common type of tracing in German-speaking lands was the *reinzeichnung* (literally "pure drawing"), in which the drawing on the *recto* was traced line for line on the *verso*, resulting in a mirror image. Tracings have been used as part of creative and craft processes for centuries, if not millennia, and Cennino Cennini discusses various ways of making tracing paper in his *Il Libro dell'Arte* (1437), the simplest being to coat thin paper with linseed oil and let it dry.

Underdrawing | Preliminary sketching, often made in *black chalk* or (in later

centuries) *graphite*, and intended by the artist as a guide for further overlying work. The overlying work was generally made in a fuller or thicker medium (such as ink or watercolor) so that the underdrawing would often, in the process of completion of the work, disappear.

Vellum | Prepared calfskin used as a drawing or writing support after being stretched, scraped, treated, and dried. This, the finest type of parchment, was made by soaking the pelt in lime, scraping off the hair, washing the skin, tightly stretching it, and leaving it to dry. The surface was then worked over with a pumice stone to smooth it. Vellum fell into disuse in the late 1400s when paper became more widely available. *Parchment* is a term that technically encompasses the skins of other animals, although "parchment" and "vellum" are often used interchangeably. See no. 16.

Verso | The "back," or reverse, of a sheet of paper. See also *recto*.

Wash | A generic term used for a liquid medium generally applied with a brush and normally consisting of a water-soluble pigment, water, and sometimes *gum arabic*.

Watercolor | Liquid medium consisting of finely ground pigments suspended in water and bound by *gum arabic*. Its transparent nature produces luminous colors, and it is often effectively used in layers. Although the origins of watercolor can be traced back to ancient Egypt, colored washes were first used widely in the 1400s and 1500s to color both prints and drawings. Many people associate the medium with the work of British watercolor artists of the 1700s and 1800s, particularly in recording landscapes (see nos. 37 and 39). Its use by amateur painters was aided by William Reeves's invention in about 1750 of ready-made dry-cake colors, which were easily transportable and simple to use. Moist, pastel-like colors made with honey as an additive were pioneered in France in the early 1800s. Given the importance of the support to the technique, the development of watercolor-friendly Whatman *wove paper* was also a significant innovation. It should be noted that watercolor washes can be extremely fugitive—vulnerable to fading quickly with overexposure to light. The term is also used to specify a work painted in the medium (i.e., a watercolor).

Watermark | An emblem or design visible when a sheet of paper is held up to the light. It is created during the paper-making process (see *laid paper*) by weaving a wire device into the paper mold so that the sheet is slightly thinner—and thus more translucent—along those lines. Initially used as indications of size or quality, distinctive watermarks came to be added by different paper mills. Watermarks can sometimes be used to assess the origins or rough date of the sheet of paper on which a work is drawn, but any information should be treated with extreme caution and in conjunction with other evidence, since the study of watermarks is far from complete. For example, many early watermarks were reproduced by later mills, and sometimes early sheets of paper were used by an artist of a much later date. See figure 6 and *Further Reading* for watermark reference books.

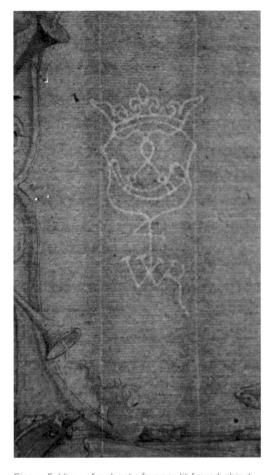

Figure 5. View of a sheet of paper lit from behind (transmitted light), showing *laid paper* and a *watermark* in the center. The watermark shows a hunting horn within a shield above the initials WR; it is found on paper made in Stuttgart around 1592 (Piccard 1971, vol. 7, p. 273, no. 205), from Jacques de Gheyn II, *Design for a Title Page*, ca. 1598–99, Los Angeles, J. Paul Getty Museum, 90.GA.135.

White chalk | Naturally occurring calcite (white chalk) is extremely common and has been widely utilized for centuries. It can be used in its natural state for drawing or *highlights*, or powdered to make *gouache*, or to prepare paper.

White heightening | Often added to drawings to provide volume or *highlights*. Heightening could be applied dry (as *white chalk* or white *pastel*) or wet with a brush (as white *gouache*). When the mixture contains lead white, it can sometimes oxidize, causing the highlights to turn a disfiguring gray.

Wove paper | Invented in England in about 1750 by James Whatman near Maidstone, Kent. The mill used a particularly finely woven wire mesh in the mold, which produced a smooth, even-textured paper especially suitable for use with watercolor. It became so famous that it was regularly forged, in particular in Austria and Germany, using a fake Whatman *watermark*.

FURTHER READING

DISCUSSIONS OF TECHNIQUE AND HISTORY

Ames-Lewis, Francis. *Drawing in Early Renaissance Italy*. 2nd ed. New Haven and London: Yale University Press, 2000.

Chapman, Hugo. *Michelangelo*. London: British Museum, 2006.

Chapman, Hugo and Marzia Faietti. *Fra Angelico to Leonardo: Italian Renaissance Drawings*. Exh. cat. London: British Museum, 2010.

Goldman, Paul. *Looking at Prints, Drawings, and Watercolours: A Guide to Technical Terms*. 2nd ed. London: British Museum Publications, 2006.

James, Carlo, Caroline Corrigan, Marie Christine Enshaian, and Marie Rose Greca. *Old Master Prints and Drawings: A Guide to Preservation and Conservation*. Translated and edited by Marjorie B. Cohn. Amsterdam: Amsterdam University Press, 1997. [Recommended particularly for discussions of paper and media]

Lambert, Susan. *Drawing: Technique and Purpose*. London: Victoria and Albert Museum, 1981. [Republished in a French edition in 1984 as *Les secrets du dessin*]

—. *Reading Drawings: An Introduction to Looking at Drawings*. New York: Pantheon Books, 1984. [A revised edition of the above]

Meder, Joseph. *The Mastery of Drawing*. 2 vols. Translated and revised by Winslow Ames. 1919. Reprint, New York: Abaris Books, 1978.

Stein, Perrin, with a contribution by Martin Royalton-Kisch. *French Drawings from the British Museum*. London: British Museum, 2005.

Strauss, Walter, and Tracie Kelker, eds. *Drawings Defined*. New York: Abaris Books, 1987.

Turner, Jane, ed. *The Dictionary of Art*. 34 vols. New York: Grove, 1996. [With artists' biographies and full entries on drawing, different techniques, and movements]

Van Cleave, Claire. *Leonardo da Vinci and His Circle*. London: British Museum, 2008.

—. *Master Drawings of the Italian Renaissance*. London: British Museum Press, 2007. [Including a good introduction on functions and techniques and suggested reading for individual artists]

—. *Raphael*. London: British Museum, 2008.

Watrous, James. *The Craft of Old Master Drawings*. Madison: University of Wisconsin Press, 1957; reprint, 2006.

Weekes, Ursula. *Techniques of Drawing from the Fifteenth to Nineteenth Centuries*. Oxford: Ashmolean Museum, 1999. [A fine introduction]

FOR AN INSIGHT INTO WATERCOLOR TECHNIQUES

Tedeschi, Martha, and Kristi Dahm, with contributions by Judith Walsh and Karen Huang. *Watercolors by Winslow Homer: The Color of Light*. New Haven and London: Yale University Press, 2008.

FOR COLLECTORS' MARKS

Lugt, Frits. *Les marques de collections de dessins et d'estampes*. Amsterdam: Vereenigde Drukkerijen, 1921. [*Supplement*, 1956]

FOR DETAILS OF SOME GETTY DRAWINGS

Goldner, George, with the assistance of Lee Hendrix and Gloria Williams. *European Drawings 1: Catalogue of the Collections*. Malibu, Calif.: J. Paul Getty Museum, 1988.

Goldner, George, and Lee Hendrix. *European Drawings 2: Catalogue of the Collections*. Malibu, Calif.: J. Paul Getty Museum, 1992.

Turner, Nicholas, Lee Hendrix, and Carol Plazzotta. *European Drawings 3: Catalogue of the Collections*. Los Angeles: J. Paul Getty Museum, 1997.

Turner, Nicholas. *European Drawings 4: Catalogue of the Collections*. Los Angeles: J. Paul Getty Museum, 2001.

FOR SPECIFIC ARTISTS
Exhibition catalogues are often the best source of further information and illustrations. For example:

Chapman, Hugo. *Michelangelo Drawings: Closer to the Master*. Exh. cat. London: British Museum, 2005.

Hauptman, Jodi. *Georges Seurat: The Drawings*. Exh. cat. New York, Museum of Modern Art, 2007.

Hendrix, Lee, Peter Schatborn, Holm Bevers, and William Robinson. *Drawings by Rembrandt and His Pupils: Telling the Difference*. Exh. cat. Los Angeles, J. Paul Getty Museum, 2009.

FOR WATERMARKS

Briquet, Charles-Moise. *Les filigranes: Dictionnaire historique des marques du papier dès leur apparition vers 1282 jusqu'en 1600*. 4 vols. Edited by Allan Stevenson. 1907. A facsimile of the 1907 edition with supplementary material. Amsterdam: Paper Publications Society, 1968.

Churchill, William Algernon. *Watermarks in Paper in Holland, England, France, etc., in the Seventeenth and Eighteenth Centuries and Their Interconnection*. Amsterdam: M. Hertzberger, 1935.

Heawood, Edward. *Watermarks, Mainly of the Seventeenth and Eighteenth Centuries*. Reprint. Hilversum, Holland: Paper Publications Society, 1986. First printed in 1950.

Piccard, Gerhard. *Die Wasserzeichenkartei Piccard im Hauptstaatsarchiv Stuttgart: Findbuch*. Stuttgart: Kohlhammer, 1961–.

See also the introduction in James et al., *Old Master Prints and Drawings*, 1997 (see above)

ON CONNOISSEURSHIP

Brown, David A. *Berenson and the Connoisseurship of Italian Painting*. Exh. cat. Washington, D.C., National Gallery of Art, 1979.

Friedländer, Max J. *On Art and Connoisseurship*. London: Bruno Cassirer, 1942.

Gibson-Wood, Carol. *Studies in the Theory of Connoisseurship from Vasari to Morelli*. New York: Garland, 1988.

Turner, Nicholas. *The Study of Italian Drawings: The Contribution of Philip Pouncey*. Exh. cat. London, British Museum, 1994.

ONLINE RESOURCES
Simple Web searches can reveal a wealth of information, although it is not always accurate, about artists and techniques. Many museums have on-line collections catalogues with excellent commentary and photography.

The British Museum Web site has further details of most British Museum drawings, and downloadable images: http://www.britishmuseum.org/research/search_the_collection_database.aspx

The J. Paul Getty Museum Web site has further details of many Getty drawings and relevant artists' biographies: http://www.getty.edu./art/gettyguide/

Oxford Art Online (also encompassing the Grove Dictionary of Art), a subscription service that is available in many libraries: http://www.oxfordartonline.com [Wide-ranging entries on technique, history, and artists' biographies]

The following is a useful online reference to drawing terms, techniques, and media, with examples: http://www.artmuseums.harvard.edu/fogg/drawingglossary.html

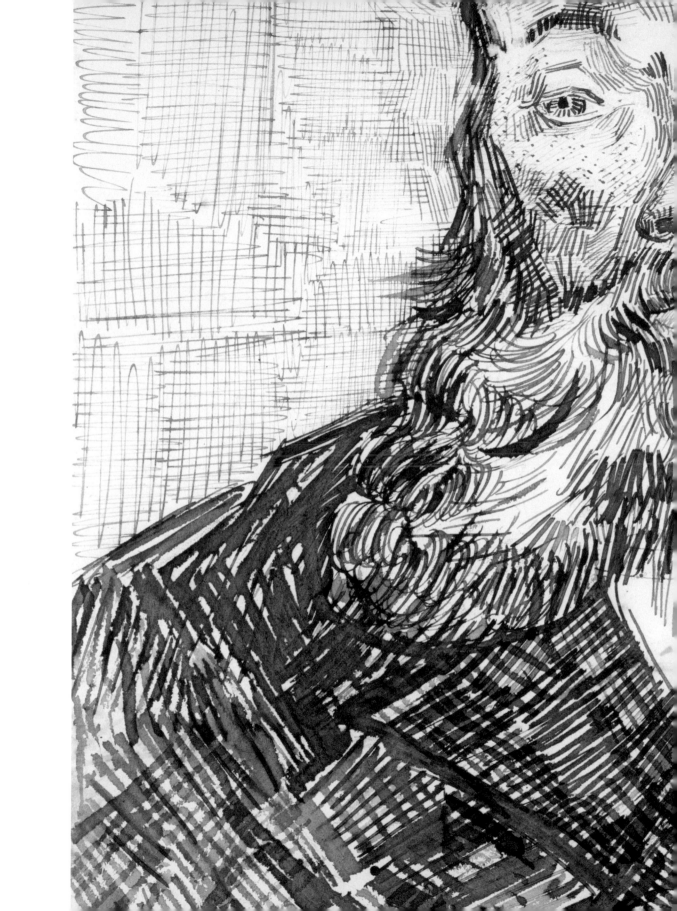

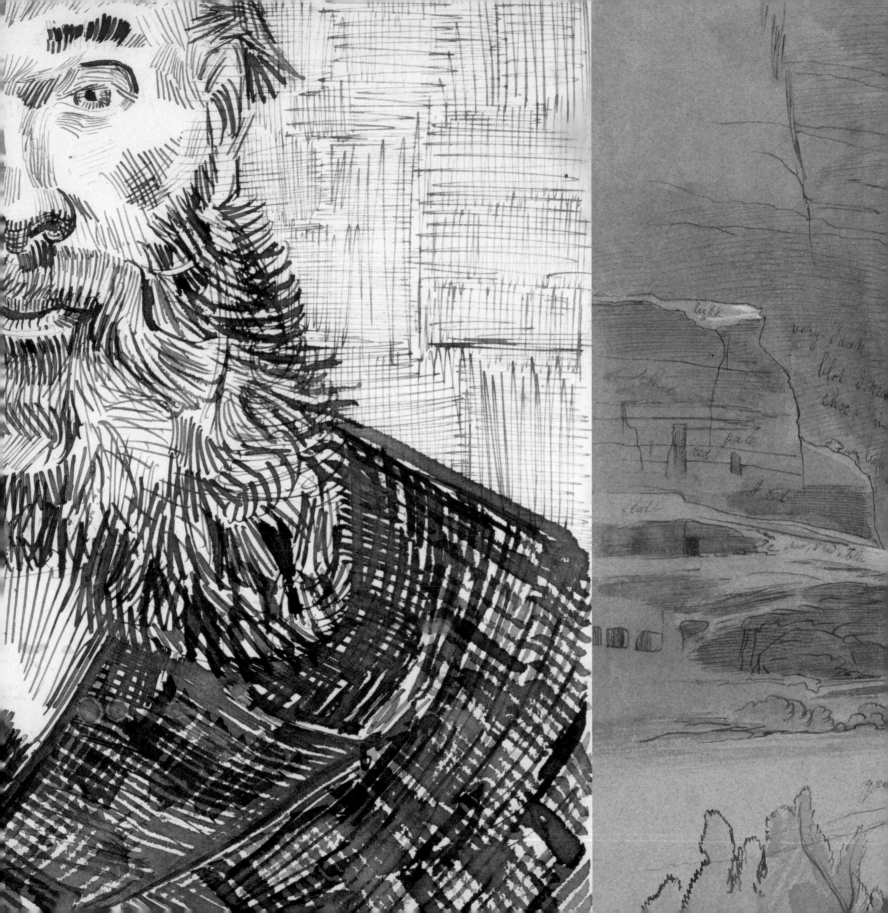

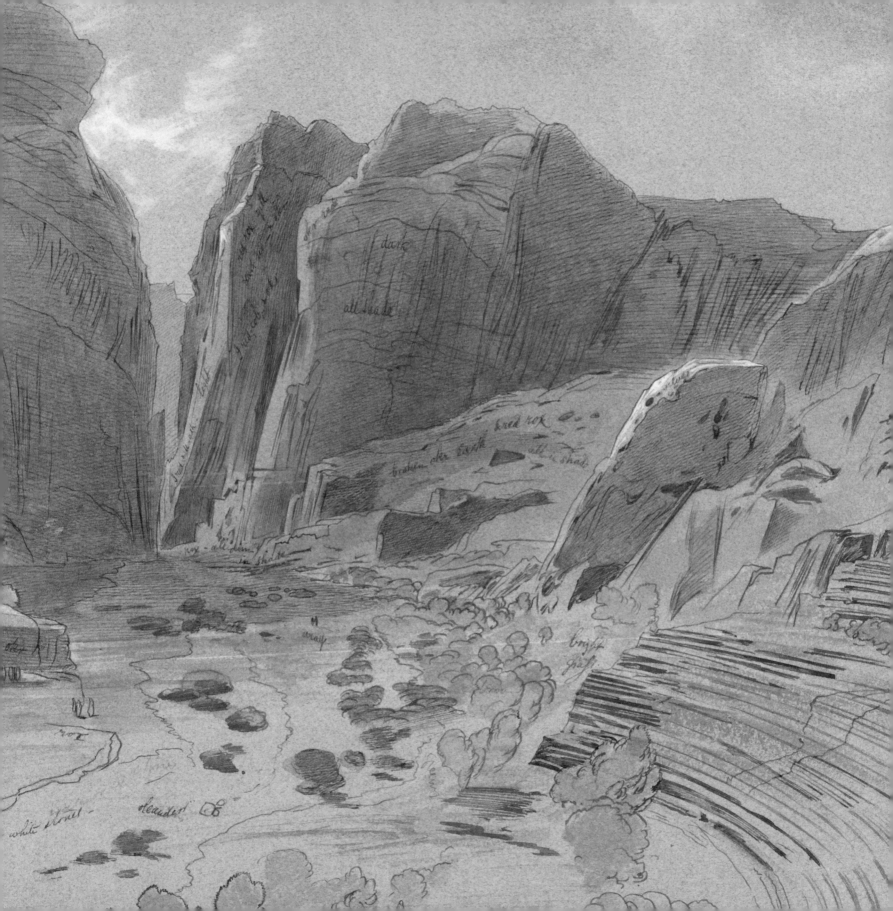

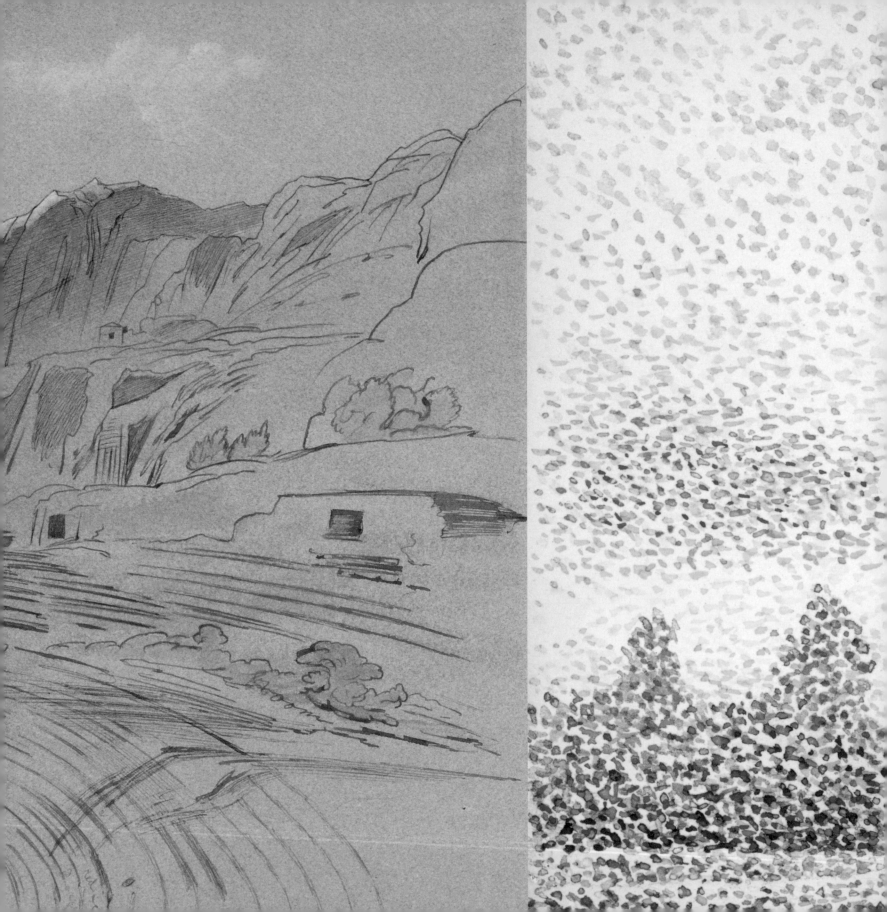